COWETA
COUNTY

COWETA

COUNTY

· A BRIEF HISTORY ·

W. JEFF BISHOP

THE
History
PRESS

Published by The History Press
Charleston, SC
www.historypress.net

Front cover: Courtesy of the Newnan-Coweta Historical Society.
Back cover: Courtesy of Lewis and Elizabeth Beers.

First published 2017

Manufactured in the United States

ISBN 9781467136693

Library of Congress Control Number: 2016953503

Dedicated to my wife, Barbara.

CONTENTS

ACKNOWLEDGEMENTS

The Newnan-Coweta Historical Society (NCHS) began in 1971 at the home of Dr. John Wells, where "several concerned citizens discussed the urgent need of preserving and protecting historical homes and buildings of the community," according to one local history. The late Herb Bridges was its first president, and I thank him for collecting, identifying and preserving so many images of Coweta County's past, many of which are included in this volume. Through the decades, many board members, volunteers and employees of the Newnan-Coweta Historical Society have put in countless hours of work to tell Newnan's story and preserve its rich history. I specifically thank Mark Wilson, who in 1999 as a student intern from the University of West Georgia Center for Public History conducted a series of oral histories that were mined extensively for this book. I thank curator Jessie Merrell and student interns Harvee White and Haley McKenzie for transcribing some of these interviews and helping to select community photos for inclusion in this book. I also thank Ellen Corker and Lauren Waldroop for their assistance with selecting and identifying images from the collection. Volunteer Joan Achee helped with digitization. Tom Camp, former NCHS president, was instrumental in helping me gather photos and interviews from the field and putting me in touch with a number of local people who shared community histories and photographs. Also of great assistance in the gathering of information and primary sources were Dick Brunelle, Elizabeth Beers, Dorothy Pope, Tom Lee and JoAnn Ray. I thank Larisa McMichael for keeping the wolves at bay so I could finish this book. I also wish to thank the

NCHS Board of Directors and its president, Lisa Harwell, without whom this volume would not have been possible.

I thank the *Newnan Times-Herald* newspaper, its owners and its staff for their crucial role in recording the town's past and for their commitment to historical preservation.

I thank my editors at The History Press, Candice Lawrence and Abigail Fleming, for their patience guiding me through the long development and editing process.

I thank Dr. Ann McCleary and the University of West Georgia Center for Public History for continued support and guidance.

Most of all, I wish to thank my wife, Barbara, and my children—Ellory, Peyton, Hetty, Sophie and Truman—who support me in everything I do. I love you.

Unless otherwise noted, all images are courtesy of the Newnan-Coweta Historical Society.

INTRODUCTION

One local history book begins with this assertion: "History is people—people who worked, learned, worshipped, and enjoyed recreation."

I take a different approach. History is narrative. History is stories. Stories are how we learn what society values and what we should value in ourselves. The stories we choose to tell—and how we choose to tell them—matter. So we have to be careful about stories. Are they true? Do they tell the whole truth?

Here's a story by a Newnan superintendent of schools, James Woodward, that was a popular one in the early twentieth century, appearing in both primary local history books, the *Coweta County Chronicles* and the *History of Coweta County*, and in the local newspaper, the *Herald and Advertiser*:

> In 1860, a State of great wealth, her people free from debt, their granaries well filled, many splendid academies and several strong colleges dotting her hills, many of her sons and daughters in our best American universities and seminaries, her society refined and lettered, her civilization chivalric and Christian, her homes hospitable and her greetings ever of welcome to the stranger, the very atmosphere sweet and happy—this was the atmosphere of the Old South.
>
> In 1865, her wealth gone, the flower of her manhood withered and mingled with the dust of a thousand gory battlefields from Gettysburg to the Gulf, from the Atlantic to the great Father of Waters; her granaries empty, her smokehouses unstocked, her schools and colleges closed, while the

> *children in tattered garments followed their mothers, many now widowed,*
> *to fields of toil; her homes once resonant with joy now despoiled and in*
> *mourning for the husband or son who is still somehow looked for, but is never*
> *to return; the social problem of half a million illiterate ex-slaves now given*
> *full freedom and citizenship; the obnoxious carpet-bag demagogue holding*
> *the reins of government over an exhausted and over-worked people—this is*
> *the Georgia of 1865.*

Whether personified by Vivien Leigh (an Englishwoman born in India) as a plucky, proud "belle" ruined by the Civil War in *Gone with the Wind* or (again by Leigh) as a refugee from the old plantation, driven mad by her enforced dependence on the "kindness of strangers" (like rapist Stanley Kowalski in *A Streetcar Named Desire*), the South—more specifically the upper-class, land-owning white South—has indulgently imagined itself as the tragic victim of history. But this romanticized version of events is only (even marginally) credible if one omits (or, more commonly, dehumanizes) half of the southern population at the time.

It is *de rigueur* in books like this one to offer platitudes of "progress" as the major theme, especially when discussing the history of the South. This is most often accompanied by a glossing over of centuries of racial and social strife. But how can we successfully gauge our progress if we aren't prepared to be honest about where we've been?

Some argue that to dredge up past conflicts and pain is counterproductive now that history has, in their minds, moved on. I would counter that humans are much the same as they were centuries ago, with the same prejudices and foibles. One need only look at the progress made by African Americans in the decades immediately following the Civil War—only to be snatched away by Jim Crow—or at the high social status and fully integrated lives of many Jews in pre-Nazi Germany, on the eve of their annihilation, to see just how dangerous it is to think that indecent, cruel human behavior is something that could only happen "back then." Progress cannot be taken for granted and should not be thought of as the inevitable result of history. To "other" history is just as self-serving and wrong as "othering" perceived contemporary menaces. Just look at how history is so often distorted to serve contemporary political ends and the truth is plain to see: the stories we tell ourselves about the past are as relevant as they ever were. If we want to have any hope of maintaining the gains we've made (or on an even more basic level, if we really want to know ourselves), it is imperative that we get these stories right.

"Stories are wondrous things," wrote Native American storyteller Thomas King in *The Truth About Stories*. "And they are dangerous."

The truth about stories, King said, "is that's all we are."

So here is a new story, then—or rather, an old story retold. If at times it seems difficult to digest, such is the food of history.

1

"THE WHOLE WORLD IS BEAUTIFUL"

Going into the country…travelling up the Chattahoochee river to the Coweta district… has afforded me a comprehensive view of the whole country of the lower and upper Creeks, and an opportunity of seeing all their largest villages.… [I]t is well timbered…mill-seats of constant water to be had…there are useful mines and minerals.… [A]t present it is but a rude wilderness, exhibiting many natural beauties, which are only rendered unpleasant by being in possession of the jealous natives. The country possesses every species of wood and clay proper for building, and the soil and climate seem well suited to the culture of corn, wine, oil, silk, hemp, rice, wheat, tobacco, indigo, every species of fruit trees, and English grass; and must, in process of time, become a most delectable part of the United States; and…may probably, one day or other, be the seat of manufactures and commerce.
—Major Caleb Swan to the U.S. secretary of war, 1795[1]

On February 27, 1925, with Coweta County poised to celebrate its centennial, the *Newnan Herald* published an account of the travels of Absalom H. Chappell from a century earlier. While in Troup County on business, Chappell had asked how he "could get to Bullsboro, the just chosen judicial site of Coweta county," newly formed from lands taken from the Creek Indians. To his surprise, "nobody could tell." Finally, the local sheriff arrived and informed Chappell that there was "no road to Bullsboro" from there and his best course of action would be to follow the sheriff to his home and then "take a trail the next morning that ran up the Chattahoochee":

I had nothing to do but to take another King's Trail…and to follow it up the river some twenty or twenty-five miles, when I must begin to look out for some route striking into the interior of the county of Coweta. He knew there was such a route, but not how far off it was. I soon found myself…in the little, narrow, well defined path, just wide enough for a single footman or a horseman, and along which no bush had ever been cut away, no wheel had ever rolled.[2]

At times, when the road divided the "tracks were so dim that I was in doubt which to take," said Chappell, and he was filled with dread that the trail "might give out" and leave him "alone in the trackless woods." Clinging to the waterways, after passing an "old Indian clearing," he eventually came to a "clear, open hill-top, with the shining waters of the Chattahoochee flashing in the sunlight before me and a plain, open road inviting me, leading eastwardly from the river." He had arrived at Grierson's Landing, just below the mouth of New River, "a place much noted in old times as a crossing in the Indian trade." Few contrasts, Chappell said, had he ever encountered "more thrilling and joyous than the almost instantaneous transition from that dark thicket to this bright scene":

As I paused for a while on the beautiful overlooking hill that sloped down to the river bank, gazing around and breathing freer, I little thought on what historic ground I was standing, or that the Eastwardly road, the sight of which was still making my heart leap, was only a very modern widening of still another Indian trail.…It had been wrought into a wagon road during the previous winter by the hauling of corn and provisions from the not very remote settlements, to be floated down the Chattahoochee from this point for the supply of new settlers on both sides of the river.

My faithful steed felt not less than myself the inspiring change from the petty trail he had been treading all day through the woods to the bright open track that now solicited him, and he sprang forward with rapid, elastic steps that brought me a little after nightfall to my destination, rude but hospitable Bullsboro—some two or three miles North of the beaten road.[3]

The county seat was removed two miles west, and the fledgling town of Bullsboro was abandoned just a year later. A new town was established along the McIntosh Road, and the original lots were sold on March 25, 1828. According to W.U. Anderson, one of the earliest settlers, "It was named Newnan in honor of Gen. Daniel Newnan," the second town in Georgia

to be given that name, following the dissolution of Pike County's original county seat. Newnan, a North Carolina native and later a Georgia politician, "served in the Revolutionary War, and was a distinguished officer in the War of 1812, and fought well with Jackson against the Indians," Anderson wrote.[4] When the town was first established, "there were two squatter settlers": William A. Hicks and James Caldwell, who operated "houses of entertainment for travelers." In addition, "Jacob L. and James A. Abrahams had a log cabin in the square with a store; this was all of Newnan then."[5] "Many good people from Virginia, North Carolina, South Carolina, and Eastern Georgia became its first settlers," recalled William Jasper Cotter in his 1917 autobiography, "and they came to stay. I have never been in a county where so many of the first settlers remained."[6]

Anderson wrote that when Newnan began there were "no schools nor churches, and we were all living on dirt floors or split puncheons to our cabins, with one door and one room for cooking, eating, and sleeping, and nearly all of us barefooted in summer from necessity of no money to buy shoes":

We then rocked our children in hollow-log cradles; men, women and children would walk five miles barefooted to a Saturday night frolic, dance all night

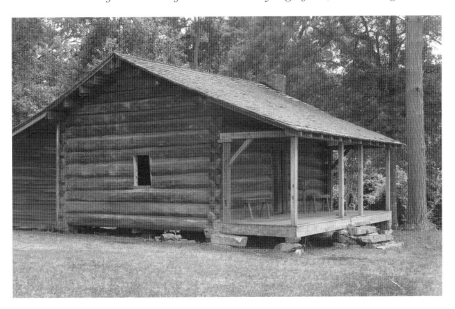

The John Coggin Meadows log cabin in Grantville is a fine example of early vernacular architecture in the Georgia Piedmont area. The cabin, built in 1828, was relocated to a city park when I-85 was constructed.

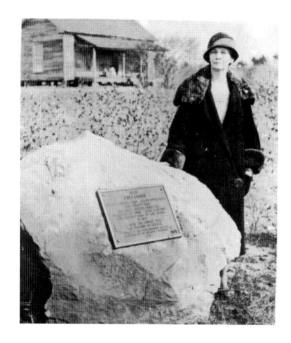

Bullsboro, the first county seat of Coweta, was established "two and one-half miles north-east of Newnan, on the Fayetteville Road," according to the *Coweta Chronicles*, whose coauthor Mary Gibson Jones is pictured here at the marker dedication in 1925.

and go home with the gals in the morning. We then thought we were as big as big Indians and as proud as anyone now with their red calico dress with a dozen tucks. All then nearly wore our own homespun. We felt proud of it, too; for it was home manufactory.[7]

Within about a month of the initial lot sales, Newnan was already home to a number of stores, a post office, a hotel, a saloon, blacksmith shops, carpenters, lawyers, a tailor, brick masons, doctors, a steam sawmill known as the "whip saw" that would "easily whip out…500 feet of lumber per day" and Methodist, Baptist and Presbyterian churches. "Others came in constantly," Anderson said.[8] "The number of travelers over the roads and Indian trails was very great" and caused many early Newnan residents to build special guest rooms to accommodate them, reported Mary G. Jones and Lily Reynolds in *Coweta County Chronicles*. One woman told the writers that "her father removed from his home on the main road and established another where he would not be called upon so frequently to entertain travelers."[9] The trail from Grierson's Landing was "widened and made into a regular road," Jones and Reynolds reported, and "settlers were coming into the new county almost in droves."[10] Prosper Johnson, "a negro, brought his mistress and the money from the sale of thirty negroes from one of the older counties, cutting a road as they came," they said.[11]

Many who came were aspiring planters. A few were merchants. Some were looking for a way to escape their pasts. Others were looking for easy money—maybe by striking gold. Accordingly, not everyone who came to Newnan stayed for long:

John Huff came [in 1830] *with three likely negroes, a horse, cart, and yoke of oxen....Huff drank considerably so that, bachelor though he was, his negroes and cart could not keep him up. Wanting money, he pawned a negro for twenty-five dollars, to work until the money was paid, giving his note—but when he went to take up the note and redeem his negro, he was told that he had sold the negro; the man producing a bill of sale, all regularly witnessed. Huff contended that it was not a sale—only a note given for the money. He sued, but never recovered his negro. Getting deeper in debt, he sold his horse, cart and oxen and left for parts unknown and his creditors to shift as best they could...but he went over to Carroll county, where the gold fever was raging, rolled up his sleeves and accumulated a handsome property, becoming one of Carroll's representative men.*[12]

Over the next three decades, much of the newly allotted land was turned into large plantations where corn and cotton were cultivated—with the engine of slave labor—producing great wealth for some of the owners and establishing a new society of aspiring aristocrats. Major Young James Long, a cousin of both President James K. Polk and David Crockett, arrived in Newnan in the early 1830s as a young attorney. He became the first solicitor of the Coweta Circuit Court and kept residences on Greenville Street and at several plantations outside of town. His in-town home (now relocated to 21 LaGrange Street) is one of the oldest extant Newnan residences—one of two dozen local antebellum homes.[13]

His daughter, Myrtie Long Candler, left behind a florid description of the privileged life of these early Newnan landholders. The one-hundred-acre plantation was a place where Major Long could "indulge in his love of nature and express the poetry that was deep in him by creating an estate that was sheer beauty," Candler recounted nearly a century later. "When I first opened my eyes, I could see some of the brightly colored tulips on the poplar trees growing out on that side beyond the stoop and the white picket fence. A faint odor of cape jessamines permeated the room the front flower yard."

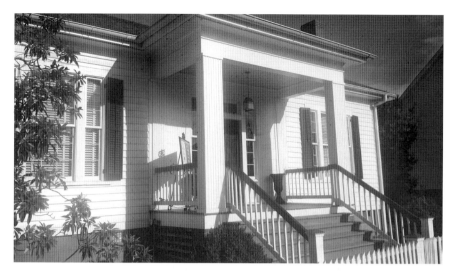

The Major Long House is one of the oldest homes in the downtown Newnan district. Originally located on Greenville Street, it has since been relocated to LaGrange Street, next to the Bob Shapiro photography studio. Myrtie Long Candler describes the Long house and plantation in great detail in her memoirs.

The home of James Kornder, 80 Charlie B. Johnston Road, at Powers Crossroads, is said to be one of the oldest homesites in the county, originally (according to local lore) functioning as a trading post when the land still belonged to the Creek Indians. The home, built by Phillip Orr, features a Federal-style sunburst fanlight over the double front doors.

The Tidwell-Amis-Haynes House, built circa 1835, is one of Coweta County's oldest homes, featuring an elegant brick Federal style more at home in Charleston or Savannah than at its 1200 Sid Hunter Road location.

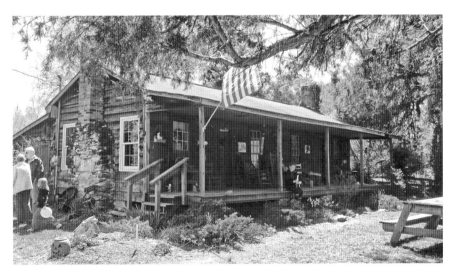

The Leavell house, currently owned by the Adamson family of Turin, is one of the early log structures on the McIntosh Trail, originally an east–west Native American wagon road.

Through the front windows, draped in white mull over deep pink paper cambric, the sun was a round ball just peeping from the rim of the eastern horizon and sending its golden rays through the pink curtains, filling the room with a roseate glory, turning the tall, rosewood bureau with its china perfume bottles and the sewing table with its little drawers, almost pink by reflection.

"The very first thing I remember is the thought," she said, "the whole world is beautiful!"[14]

2

"AN ORNAMENT TO THE HOUSEHOLD"

I was born in Newnan, Coweta county, Georgia in the prosperous days of the middle eighteen fifties," wrote Candler, "in the era when the great plantations flourished; when Cotton was King and Georgia was the heart of his kingdom."[15]

Candler described her Scotch-Irish father as "first and always" a cotton planter who "practiced law for recreation," an Indian fighter and patriot, whose sprawling estates contained "all the adventure that my heart desired":

> *Pa was a large, strikingly handsome man and was always fastidious in his dress. He wore that kind of broadcloth which I think is not made any more. I have not seen any in a long time, compactly woven, and with a rich gloss. He accepted the many sided responsibilities of his life with grave cheerfulness. The support of almost a hundred people rested in his judgment.*[16]

Those one hundred people included slaves, or "servants," as Candler referred to them. Slaves accounted for roughly half of Newnan's population. On the eve of the outbreak of the Civil War in 1860, there were 14,703 people living in Coweta County. "Of that number, 7,449 were free, white citizens and 7,248 were slaves." In the town of Newnan, slaves actually outnumbered whites, according to the *History of Coweta County, Georgia*.[17]

Myrtie Long Candler described those who lived with her family as her "earliest friends."

Black Mammy *was the most tenderly beloved of all. She was the general head of the household, the family adviser and nurse. She was trusted and respected. From infancy I was taught to regard her as perfection. She was faithful, truthful, dependable, kind, loving, and wise. She had suckled one of the older children. She nursed us all when we were ill.*

Black Mammy was little and dainty, and dully black. She was born and reared in Virginia and was said to be descended originally from the Guinea tribe. She was gentle of manner and soft voiced. She did not wear the uniform of the rest of the household, but dressed in pretty colors, usually cotton fabrics with a design of lavender vines or sprigs on a white ground.

Her cabin was as dainty and sweet as she was herself. Outside in her yard grew zinnias and prince's feathers. Inside was coziness and artistic charm, and her walls from ceiling to floor were completely papered with prints from Godey's Lady's Book. *Sometimes I would call upon her in her house. She would receive me with a little graceful formality that was charming. She would bake me a piece of ash-cake on her hearth and serve it to me, and by her innate courtesy she managed to make me feel like visiting royalty.*

Uncle Antony *was Black Mammy's husband. He was the carriage driver and was responsible for the care of certain of the finer horses. He was black with small, honest features. He was competent and faithful and deeply respected by all the family.*

Ben, *a youth of nineteen, had inherited the noble qualities of his father and mother, Uncle Antony and Black Mammy. He was my brother Grantland's man.*

Henry *was about thirteen, and the best little Negro that ever lived on earth. Henry (and Joe) made the fires all over the house. There was always a bed of red coals and they together brought in the cut wood and stirred the slumbering fires to brightness. In each room they put a big backlog and some rich split pine "lightwood." By the time the family got up there was a beautiful, blazing fire in every room.*

Alf *was the most formally trained of the retinue. My mother was exceedingly proud of him. He was always meticulously dressed in white linen. He waited on the table, answered the door and served refreshments to callers. He was intelligent, polished, and an ornament to the household.*[18]

Candler goes on for several more paragraphs in this manner. I had a friend of mine read these descriptions. She smiled and said she had no idea whites "were so nice to their slaves" and spoke of them so tenderly. I must admit, her reaction shocked me. While it would be wrong to judge these writings using today's social mores, it is imperative that we understand that when Candler says Henry was the "best little Negro that ever lived on earth" or that Alf was "the most formally trained of the retinue," she is using the kind of language we reserve for pets, not fellow human beings. The tone is patronizing at best and dehumanizing at worst. This was the language of the "happy slave" or "Sambo" stereotype so common before the Civil War. Black people were described by those in power as meek, simple-minded, servile and content. This stereotype served well those who wished to rationalize enslavement to fulfill their own economic self-interests. As the times changed, so did the racial stereotypes. (After the Civil War, describing black people as happy and meek no longer served the purposes of those in power, so a new, even more treacherous stereotype would soon develop, as we shall see.)[19]

To perceive the true attitudes of the slaveholding class, one need only read some of these passages more carefully. Alf, who may have been called a "butler" in England, Candler mused, had come to her mother from her "bachelor uncle" in Virginia. Her mother's attitude toward Alf and the rest of the slaves on the Long plantation may be best inferred through her reported reaction to a popular abolitionist book of the time. "I never saw Ma lose her temper but once," said Candler. "She was sitting in the hall reading a book. Suddenly she stood up and said: 'PSHAW!' With that she hurled that book the full length of the hall. It lay there on the floor with its cover upturned. My brother read the title aloud, *Uncle Tom's Cabin*."[20]

About a mile north of the Long residence lived a fellow law practitioner and slave owner, Judge John Ray, originally from Drumstevlin, the Donegal province of Ulster, Ireland. "Acquiring a good education and a knowledge of literature and history, he longed for the wider opportunity offered an ambitious young man in America," according to his biographical entry in the *Chronicles*. Governor Joseph E. Brown said Ray was "prominent as a lawyer, advocate, and Democratic orator in Western Georgia. Honorable, honest, consequential in air and manner, sensitive and brave, suspicious of foes, and confiding in friends." His "hospitable mansion," as described by Civil War–era nurse Fannie Beers, was formerly located at the corner of what is now West Washington and College Streets. Ray lived there from the founding of Newnan until just after the war. "Having inherited refinement

and acquiring wealth and culture, Mr. and Mrs. (Bethenia Lavender) Ray maintained a handsome home that was notable for its generous hospitality and for the beauty and lavishness of its entertainment," according to the *Chronicles*. "The home was almost never without a guest.…Much of Judge Ray's means was invested in plantations and negro slaves, whom he cared for as his children, who gave him devoted service in return."[21]

Judge Ray's actual children included Lavender Ray, later to become a noted lawyer in Atlanta, and another son, John, for whom the community of Raymond was later named. Robert H. Harris described the Ray brothers fondly in his short essay *Little Newnan Boys of the Early Fifties*:

> *Some of these names are only vaguely remembered; but here are two about which there is not a shadow of a doubt—John and Lavender Ray. Being asked by his teacher how the earth is supported in space, John forgot what the book said (if he had ever known it) and answered promptly, "Dey holds it up wid a great big rope." We all laughed.…On being asked his name by the teacher at the opening of the term John's brother, Lavender, replied: "Yallender Yobinson Yay," but everybody called him "Paddy"—because his*

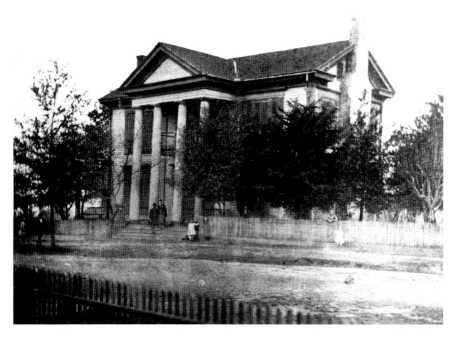

The Judge John Ray home was located on West Washington Street, at the intersection with College Street. It is now the parking lot for the First Baptist Church.

father was Irish, I suppose. And he was as game as any Paddy that ever "shinned up a mast" in a storm or charged a battery.

Harris recalled that once, when they were boys, the local postmaster engaged them to rid the post office building of a yellow jacket nest. "We organized and drew for places in the assaulting column," said Harris. "Paddy drew No. 1, and his part in the attack was to rip off the plank covering the sill and dig out the nest with a sharp stick." Several other boys lent support, and "perhaps a hundred men and boys stood around as spectators," he said. "Paddy ripped off the plank and dug out the nest, completely destroying it," said Harris, ridding the post office of the yellow jackets, but Ray was attacked by a swarm of them, "scores upon scores," and had to lie in bed for days from the swelling. The boys were paid for their pains with one "thrip" each—"a piece of silver half the value of a sevenpence, old Federal coinage, worth $12\frac{1}{2}$ cents":

Many of these found their way into the pouch of the old black mammy called "Aunt Synie," who sold gingercakes and persimmon beer at a chosen corner on the street. Don't know whether she was a slave or not; never inquired. In fact, we little boys knew nothing about "slavery," and cared less. We played with little "niggers" of our size, "wrastled" with them, went "a-fishin'" with them—and that was the end of the matter with us.[22]

Morgan Ray, a slave of the Ray family, asserted that the reason Judge Ray may have at times cared for slaves "as his children" was because some of them were, in fact, his descendants.

"I wants to call your attenshun to John, for he wuz my daddy," said Morgan Ray in his Works Progress Administration narrative. "When my motha [Louise] was only 13 years old, John done took advantage of her at de point of a gun. I was the result. I wuz born May 28, 1853."

"My motha never did forgive my pappy for what he done to her, nor I either," said Ray. "Long after the war my daddy offered to give me 25 acres of his land for my very own. I wouldn't take it then and I wouldn't take it now."

Ray told his interviewer from the WPA (which recorded its narratives in "dialect" form) that he was of mixed African, European and Native American ancestry, and the interviewer confirmed that Ray's appearance seemed to validate his assertion.[23] "He is a mixture of Negro, Caucasian and Indian, and, in his features, the Indian predominates," it states in the WPA report.[24]

A February 1906 obituary of another former slave of the Ray family, Dick Thompson, related that Thompson "was born in that part of the Cherokee nation now included in Floyd county, in the year 1832. His mother was a negress, his father was a Cherokee Indian," likely named Archy Rowe. "Mother and son became property of George M. Lavender, who moved there from East Tennessee" and operated a trading post at the Major Ridge home on the Oostanaula River near what is now Rome, Georgia. "After the death of George Lavender, in 1839, Dick became the property of his sister, Mrs. John Ray, of Newnan, and was assigned a home on the White Oak plantation, now owned by Capt. John D. Ray":

> *In 1852 Dick married the daughter of the "black mammy" of the plantation. His good character caused him to be promoted in 1856 from farm hand to carriage driver for his mistress. This place he held until July, 1861, when his young master, Lavender Ray, went to the war. Dick gladly accompanied him as his servant and cook. By reason of what he had learned as a cook during the war, Dick became proficient in the art of barbecuing meats, and at every barbecue in and around Newnan he was called upon to preside over the pit.*[25]

"To know Dick was to be his friend," wrote Lavender Ray in 1906. "No matter how long the march or cold the weather, Dick never failed to have the meals ready on time." Ray rhapsodized that Dick faithfully followed him from the "attack on Cheat Mountain" to the "fires which consumed Atlanta," at his side even when it was "a test of endurance, the weather was so cold—sticking to his master though five other negroes deserted their masters there."[26] Morgan said that he remembered when John Ray, who had joined the Newnan Guards, Company A, First Regiment of Georgia Volunteer Infantry, "rode away with one of de slaves" who "went along to be my daddy's servant" during the Civil War, but he returned after a close call in battle.

Morgan Ray said that he, like Thompson, was of Cherokee descent. "You can look at my me and tell by my high cheek bones and my red coloring that I ain't no full-blooded Negro," he said.

> *My grand-mammy wuz a Cherokee Indian squaw….I dunno where she met and married my grandpappy, I fergit if mammy ever told me. Alls I knows is dat my motha was sold to…a big plantation and 500 slaves near Newnan, Georgia, 39 miles from Atlanta. She was about 12 years old at de time…* [and] *she looked much more Indian den cullud, likes I do.*[27]

Louise told Morgan that she worked in the cotton fields when she was a girl and was promoted to "cookin' in de big house" when she was older. "But I members she often sat up all night spinnin' and makin' suits," said Morgan. He recalled that in the summer he wore a "sort of a shirt like a nightgown," and in the winter, he "wore a suit of jeans." But he "nevah heard about Sunday clothes den" and attended church a short distance from the Ray plantation "in the one suit I had to my back." The slaves sat in the rear of the Baptist church, he remembered, and the preacher would urge them to "behave" themselves and not run away, to "obey our masters."

Learning to read and write was punishable by whipping.

> *I nevah got no learnin' in slav'ry times, and I nevah heard of any of the niggahs in my parts what did. If Marse Charles Henry had caught us tryin' to learn readin' and writin', I 'spects he would have whipped us hisself. It's only in late years dat I learned to read print, so's I could read my Bible. I don't do much writing even now.*
>
> *My stepfather, whose name wuz Fields, did learn to write his own name, I recollects. This is how it happened. When he was a boy he was sent to carry the books home for de school chillun. On de way home he would get de chillun to write different things on a slate or on de ground by bettin' em dey couldn't do it. After my stepfather's trick was found out, the chillun were told not to write or teach him anything more. But not before he learned to write his name.*[28]

Although he was never whipped as a boy, Morgan Ray said he witnessed his mother, Louise, being beaten repeatedly.

> *I allus liked my old Marse Charles Henry. He wuz Irish and he was a lawyer as well as a plantashun owner, and his law work done keep him away from home a lot. But I recollects that he was awful good to us cullud children. He used to pull our ears and pinch our cheeks and tweek our noses. But he never done beat us. Sometimes he used to let his over-seer whip my mothah though. She was high spirited and hard to boss. I members once of cryin' and cryin' 'cause my mothah got a lickin'. What for? My pappy had her beat 'cause she beat me. I 'spects I needed it. But he was furious when I told him about it. He had her arms tied and had her lifted up till her toes just touched de floor. That wuz 'cause she fought so hard to keep from gittin' a whippin'. It took three men to lick her dat time. 'Deed it allus took two or three men to punish her, she used to brag, after she got freed.*[29]

John Ray wrote out, at great length, his "Rules for the Treatment of My Slaves by the Overseers," preserved in its entirety in the *Chronicles*. The overseer "must keep his temper in check" and "never whip in a passion," per Ray's precise instructions. "All hands must obey the Overseer in all matters in and about the plantation and work—must not disobey orders given, must do the work as directed, must not be impudent." He directed:

> *If any negro should resist the Overseer when he goes to whip one, he is to call on two or three of the men to tie him and they must obey him promptly.*
>
> *Women and boys are not to get more than fifteen to twenty-five lashes with the strap—or small switches—to whiten the skin, but in no case to cut the skin; never giving more than ten lashes at a time without stopping a minute or two and talking to the negro, then resuming the whipping—if necessary—until humble, and he promises to do right, then take him or her on this promise.*
>
> *Never scuffle or run after a negro, if possible they must obey and stand and not resist at any time, if they do it shall be worse with them at all times.*
>
> *All punishment to be increased or diminished as the circumstance of the case seem to require in order to maintain good order and government in all matters, and for all persons…*
>
> *Whip…on the legs and thighs and butt, but never on the back; never be cruel, but be obeyed, and govern firmly and promptly—Make them love and obey you. When they do well, encourage them and show them you are pleased; keep them in good heart and spirits and stimulate them, be at their work.*[30]

Other local slaves related similar stories of cruelty. Millie Garnes told the WPA that her father was "brought to that country with a gang of slaves in chains," originally destined to work the cotton fields of the Louisiana "Delta country." Instead, "Father was sold to a man at Noonan, Georgia," she said.

> *Dis man was so mean to him that he run off.…Dey hunted for him with dogs but didn't catch him so his master sold him to another man dere in the woods. He was finally captured and his new master wasn't no better to him than his old one was. He whupped him mighty hard and give him hard tasks to do. If he didn't do the work that he was 'lowanced to do he was whupped. His master said he was gonna break his nasty, mean, stubborn will or kill him trying.*

Garnes said that her mother belonged to the Allen family in Newnan. She said:

> *Dey wasn't good to none of their slaves either….Mother had to work from daylight to dark. She would work in the field all day and wash for the family at night. Dey wouldn't 'low her to lose no time out in the field during the day time. She had to use the battling bench and stick to clean the clothes and dey had to be clean, too, I can tell you.*
>
> *I've seen scars on her back where she had been whupped. She was whupped till she was unconscious lots of times. Dere were scars on her feet, too, where she went barefooted on frozen ground and cut her feet.*[31]

Cruelty toward people of color was even part of the local law. An 1852 Code of Ordinances stated that "any slave or free person of color found on the street after fifteen minutes past nine o'clock without a permit of owner or guardian shall be given twenty lashes." Free blacks had to pay $100 just for the privilege of living in town.[32] "De Paddyrollers in slav'ry days wuz like policemen," recalled Morgan Ray. "Slaves warn't allowed to leave their plantashuns or farms without gettin' a pass from de overseer. If de Paddyrollers stopped you and you ain't got no pass, dey would give you a beatin' and send you back home."[33]

Even though President Abraham Lincoln issued the Emancipation Proclamation on January 1, 1863, declaring all people held as slaves in "rebellious states" to be free, word of this act generally did not reach Southern slaves until after the South lost the war.

"I heard a lot about de war, but I didn't know I was free till after de war wuz over," recalled Morgan Ray. "I guess de war was too far away for me to worry much about it at first. Den I suddinly got de idea it wuz pretty close when I saw my pappy in a gray uniform and aridin' a horse."[34]

Ray said at first many of the slaves were afraid of the Federal troops because they did not understand their intentions. Accurate information was almost impossible to come by. "I suttinly wuz very excited when I heard de raidin' Yankees had burned de town of Newnan close by Marse Ray's plantashun," Ray remembered, even though, in truth, the town of Newnan was never burned. "I thought dem Yankees were scalawags for sure. It warn't till later dat I found out de Yankees had come down souf to free us slaves."[35]

Near the end of the war, on February 14, 1865, Lavender Ray proposed in a letter home to his father that slaves throughout the South be enlisted to help fight for the increasingly desperate Southern cause:

What is your opinion about our present situation? It appears gloomy enough, but I hope and think we will yet be independent. Our only hope is to fight until we conquer a peace…

I regard the Negro as the prime cause of our separation from the old Union, and it is humiliating to have to surrender one of our greatest institutions, both for the prosperity of our country and protection and civilization of the black race, to popular opinion of other nations. Yet, I think this will have to be done, sooner or later, and I believe Congress is of the same opinion.

If so, why not make the Negro useful to us in achieving our independence? We can put 100,000 in service and discipline them so they will do good fighting.[36]

Three months later, the war was over. Candler remembered her father's act of informing the slaves of their freedom as a kind of *mea culpa*:

The Cause was lost. The South had surrendered.

Pa called the negroes together. I remember they were all standing in the back yard. He stood on the steps and talked to them. His face was grave and earnest. He spoke very kindly. He told them they were all free now to go where they would and do the best they could for themselves; but that those who wanted to stay could do so and that he would do the best he could for them. I remember the fright on the faces of the older negroes and the helpless expression on my father's face. There was no money. Our Confederate currency was now waste paper.[37]

Garnes vividly recalled black children playing "with great rolls" of the worthless Confederate currency after the war. "It was Confederate money and wasn't worth nothing," she said. "I've seen rolls of it as big as my arm….My mother bought her the goods to make her a worsted dress and give two hundred dollars for it."[38]

When the Rays finally informed the slaves that they were free to leave the plantation, they erupted in jubilant celebration, Morgan Ray said:

Dere wuz great rejoicin' among us niggahs when Marse Charles Henry done told us we wuz free. He acted very kind and mellow-like, told all de hands dey could stay and work for him on de plantashun. He didn't seem to have no life about him at all. You see he counted much of his wealth in de slaves he owned.

A lot of de hands stayed on de plantashun and got as dere pay three or four pounds of meat a week and about six dollars a month. But I wuz itchin' to get away, so I left and got my first job workin' for a Dr. Hill, who owned a plantashun at Oak Tree, Ga. I think he paid me ten dollars a month and my keep.[39]

Garnes said that they, too, remained on the plantation for a short time. By this time, her family had come to the farm of Terry and Mary Harris, whom Garnes described as more benevolent than previous plantation owners.

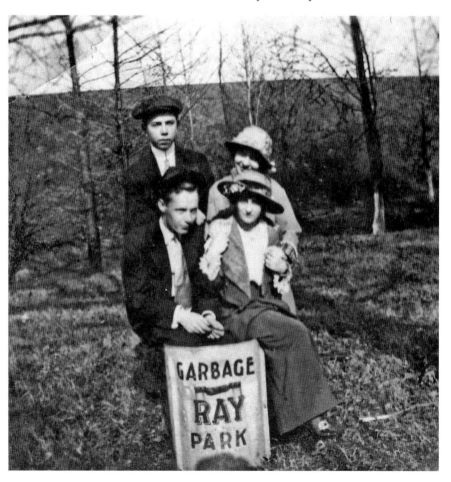

The Cook family enjoys an outing at Ray Park in Newnan in the 1930s. The park is located on Spring Street.

When the war was over, father and mother stayed a year with Master Terry, and den he leased some land and cleared it up and built us a house. Father still worked for Master Terry, and he paid us in meat, lard, corn and other food stuff. We never did go hungry but got along purty fair. Miss Mary gave mother a start of chickens.[40]

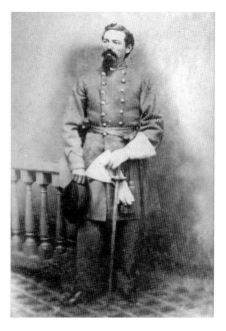

Lavender Ray, who had fought with Stonewall Jackson in Virginia and future Ku Klux Klan founder Nathan Bedford Forrest at the capture of Murfreesboro, always with his servant at his side, at the "close of the war…returned to Newnan and, following his father's footsteps, he studied law and was admitted to the bar in March, 1866," according to the *Chronicles.* His brother, John, a cavalry captain,

Lavender Ray, a Confederate officer and an Atlanta attorney, was known around Newnan as being one of the "unreconstructed." He refused to pass under the U.S. flag.

returned to his White Oak plantation and became a successful planter, marrying and establishing "an attractive cultured home…where they inaugurated and conducted many movements for community up-lift." Lavender remained one of the "unreconstructed," however, refusing even to pass under the U.S. flag that now hung over Newnan:

E.S. Buchanan tells of Captain Lavender Ray leaving church on Sunday, whether designedly or not, jay-walked across the street before reaching the flag; a sentry posted there got in behind him with pointed bayonet, but Captain Ray paid no attention, but leisurely, without looking around, took his way homeward—out West Washington street—reaching the Baptist church, where the congregation was passing out, many took note of the militant sentry, and such a big crowd gathered with angry words and looks that he seemed to decide suddenly that he had gone far enough, for he turned and stalked back to his post.[41]

Both Lavender and John's families eventually relocated to Atlanta, where they had "accumulated large real estate interests." But before leaving town, the Ray family deeded to their beloved City of Newnan "several acres of land centrally located to be known as Ray Park as a token of…lasting affection":

> *That the said Lavender Ray for and in consideration of the attachment he hath for the said city of Newnan as the place of his birth and his home for forty-eight years, and the regard he has for the memory of his father, the late John Ray…hath…before the removal of his residence to Atlanta, given, granted, and conveyed…unto the city of Newnan, to be held, improved, and used and occupied as a public park.*

This gift "marked the noblest gift in the history of Newnan up to that time," according to the *Chronicles*, "permanently enriching his native town."

There was only one caveat: Ray Park was to be for the "exclusive use and benefit of the white citizens of Newnan, their white friends, and its white visitors and sojourners." The faithful "friend" and battle companion Dick Thompson, the longsuffering and ill-treated Louise and even blood relative Morgan Ray were not welcome.[42]

3

"SICK WITH HORROR"

The year 1861 was one "that will long be remembered in the history of Coweta," according to Anderson, "as she furnished the first company in the regiment from the state of Georgia" for infantry in the Civil War—the same company enthusiastically joined by the Ray brothers and many other local youths. "This was the year of secession," remembered Anderson. "We will, if we can, procure the names of all the soldiers from Coweta county in that war," he wrote in his *History*. "Insert them that they may be remembered by ages yet unborn." Those names, oddly, were never listed by Anderson or "inserted" by anyone else.[43]

One of those youths never mentioned by Anderson was Joseph Woodson Parks. Born on October 21, 1843, Parks was just seventeen years old when war broke out. Of the wealthy planter class, Parks was away at school in Oxford, Georgia, when he received a letter from his mother, Clara Ann, in May 1861, urging him to ignore the gathering clamor for war and continue his studies as planned:

> *All can't go at one time & more have offered their services than <u>can be received</u>. So all you have to do is study and attend to the improvement of your mind.…As to cavalry, you have no horse and no chance to get one. It is all I can do if more than I shall be able to do in these times to raise money to pay your expenses and I have <u>undertaken</u> to send you this term; think it is the least you can do to apply yourself and improve the opportunity afforded and not be talking about wanting to go home like a little 10 year old boy*

and suffering your mind to be diverted because there is an excitement in the country—Hope you will attend to your proper duties and let the excitement take care of itself. When you are grown then will be your duty to take an active part in the affairs of life.[44]

He didn't listen. (Emory College's administrative decision later that summer to close the college for the duration of the war probably made his decision to join the Seventh Georgia Infantry that much easier.) While his previous letters had catalogued items like partridge hunts, class examinations, fraternity halls, libraries and the "beautiful grove" in which the college campus was situated, Parks's next letter home to his brother in January 1862—addressed from Camp Centreville, Virginia—was of a notably different tenor:

I received the clothes, the pants and coat. But unfortunately they are too large but I can wear them. The chief thing that I wanted was a bed quilt. I told you a dozen times before you left to be sure to send me a quilt the first possible chance but it seems that since you have got to lay upon beds of downy lace, that I am no longer thought of. I thought I would get all necessary things after you got home, as you knew what was needed in camp.

You didn't say how much cotton or meat we had. I was glad to hear that you were attending to our farm for I know you will do better than anyone else. Will Sis go to school this year or not? I hope she will not.

Tell Mama to send me some bedclothes the very first opportunity and some eatables…

If you all dont send me some bedclothes I never will write for anything else, dont think that I am mad in the least, but I do think you ought to send me some cover.[45]

Four days later, Parks wrote to his mother that he would not be able to attend to the family farm "so long as the War lasts." He said that to remain at home would be "<u>very</u> wrong…while an enemy of the most detestable character is dealing destruction throughout our land." The worst thing Parks had to deal with thus far had been the weather. "The snow is shoe mouth deep all over the ground," he told his mother. "We are in our old worn out tent [and] it will be a week before we get our quarters fixed. The weather is very cold. I got up this morning and found snow in my boots and on my blanket and every where else." He had also suffered from jaundice for about a week, he said.

Things got worse very quickly. On March 19, he penned an extended account of his regiment's hasty retreat from Centreville to a camp near Orange Court House. "I reckon you all have become troubled about us as you have not heard from us in so long a time," said Parks. "You may probably suppose the Yanks have captured us, but if you do you are very much mistaken, for we have been spending the last ten days in getting out of their reach." He told his family that he and his cousin Albertus "Al" Parks were now camped two miles from the dwelling and grave site of President James Madison. "Albertus & I have been over there this morning. It is the prettiest residence I ever saw," Parks said. He asked his mother to excuse "dirty places on the paper" because he had been forced to press down on the back of his canteen, and he had to write with a "cedar pencil" because there was no ink. "I will send you some ivy from President Madison's graveyard," he said. On April 6, he wrote from "Camp Madison" that Al had left camp without authorization to visit sick relatives. He said Albertus felt he had no choice but to leave due to the letters he had been receiving describing his "family in such distressing circumstances," causing Al "great trouble and uneasiness." Parks said he feared Albertus might be court-martialed if he didn't return soon. "You stated in your last letter that it was difficult for you to read my letters," Parks told his mother. "You must take into consideration the disadvantages we labor under in camp, but so long as you receive letters with my name you may feel confident that I am yet in the land of the living."[46]

Word soon came that Albertus's worst fears had been realized and that several of his family members, perhaps suffering from the measles, had passed away, including Albertus's father, whom Parks referred to as "Uncle John." "These are truly times of sadness, as regards our relatives," said Parks. He asked his brother to assist their cousin in "every possible way" and to tell Al to "get a discharge" so that he could take care of business at home.

An undated letter relates that Albertus soon returned to the battlefield, however. Parks had been posted to the picket line, near Richmond, which was mostly quiet duty, as he described in a letter to his mother on June 24, 1862:

> We are now on picket. Our post is about one hundred yards from the Yankee post, we never shoot at each other on our posts. The Yanks & our men meet each other frequently, though it is positively prohibited. They exchange papers nearly every day. I think it wrong, the Yankee pickets say that they are ordered not to shoot at us until we shoot at them. The musquitoes are far more troublesome in the picket posts than the Yankees are.[47]

This would soon change. On a Wednesday morning, as related in a separate and undated letter, "a pretty brisk firing" erupted between the pickets. Albertus and Joseph Parks were ordered to throw off their blankets and "prepare ourselves for a fight," said Parks. The general said that he had "never seen such thick shelling in his life," he wrote. "It seemed to me that the enemy had found out our precise position, for every shell looked like it fell in our midst. You never saw boys stick their heads so close to trees in your life." Albertus and Joseph were lying side by side when "a bomb busted & a ball fell in reach of us, but did not touch either of us," said Parks:

> *I got up on my knees to get a drink of water out of Al's canteen, he told me lie down that the balls would kill me. These were the last words he ever spoke to me. [When] we were…ordered to change our position to the rear…we had not gone 10 steps before Al was killed by a bomb, taking off the top of his head….I did not know that Al was killed until we stopped to load. Billy Overby said to me that Al was dead, but I did not think he was, so I got up & called Al, but he did not answer me. I was going back to see about him but Col. Wilson rode up & said that he was killed instantly.* [48]

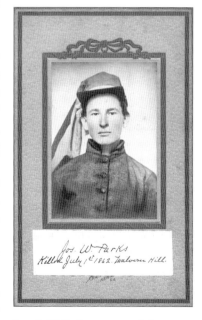

The same bomb killed another soldier nearby, going "through his breast," Parks said, and taking off "one of his arms except hanging by a little piece of skin." Parks had no time to process all of this, however, as soon the general was ordering everyone to retake their entrenchments.

Parks survived the battle, but by this time, death was no longer an abstraction. Urged by some family members to make a will, Parks said that it was unnecessary. "There will not be enough to will any body," he joked.

His last notes and letters showed that Parks had the comforts of home more and more on his mind: He asked his mother to "fix me up a nice bag of eatables, such as ham, sausages—5 lbs, lard—10 lbs, butter—10 lbs, cakes, jelly

Joseph W. Parks was wounded at Malvern Hill during the Civil War and died on July 11, 1862. He had been enlisted for just under one year and was only eighteen years old.

& such things, also wine & brandy & send it to me." He also asked one last time for a heavy quilt.

"I believe all the boys have got eatables but me," Parks lamented. "I have never received the first thing yet. If you will send it, let me know if you will. If not, it doesn't make any difference."

In a separate letter, also undated, Parks wrote to his mother:

> *The money I sent home, I intended it as a present for you, use it as you wish. I will send more when we draw again, though we draw so little that we can hardly make out with. I have to buy a good many things & pay about three prices for everything. I will ask you some questions which you must answer in your next letter. Did we make enough corn & meat? how much cotton did we make? how much have we sold? where are your negroes & Ishy's? will sis go to school? is T. attending to our lands? did John Ira get in that near ground? how much did he clean up? You need not show this to anyone, Mama. Tell Tomy that Dennis bet on Henry playing cards several times while he was out here & won about 40 dollars. I just found it out a few days ago. He ought to be whipped for it. Show this to no one. J.W. Parks[49]*

Joseph W. Parks was wounded in the Battle of Malvern Hill, Virginia, on July 1, 1862. He died on reaching Richmond ten days later, on July 11, 1862. He was eighteen years old.

His home of Newnan was far from the battlefield for most of the war, its residents learning of the horrors of the conflict mostly through the newspapers and, more immediately, from letters like those of Parks and other loved ones. As Candler recalled, "Early in 1863, the spirit of everything changed. The world was no longer a place of eager joy and dreamy romance. Grim realities were forcing their way into my scheme of things":

> *News came thick and fast. Cousin Young had been killed by his horse; Cousin Sammie Townsend, Aunt Sarah's son, 13th Regiment, Georgia Volunteers, was dead. Cousin Billie, Aunt Nancy's boy, had been killed with many soldiers of his regiment in a railroad accident. Cousin Ben Long, still alive and the captain of the company he had organized, was in the thick of the fight. Cousin Bob, with five little children at home, was fighting at Gettysburg and the Wilderness. My brother, Grantland, was now one of "Joe Brown's Pets"…thrown into the fighting around Atlanta.[50]*

On September 9, 1863, "Dr. Carey B. Gamble and his surgeons arrived in Newnan, searching for hospital accommodations," according to a brief account written by Judge Byron H. Mathews Jr. "He took over a hotel known as the Coweta House, the courthouse, and all large buildings and stores on the Court Square. Wounded from the battles in Tennessee, the Battle of Chickamauga, and the many engagements in the Atlanta Campaign began to pour into Newnan. Every train thereafter seemed to arrive loaded with misery."[51]

Newnan was a prime spot for a hospital due to its location on the Atlanta & West Point Railroad and its distance from the fighting. Seven Confederate hospitals were established. Sheds twelve feet wide by one hundred feet long were erected on the courthouse lawn to accommodate the wounded. "More than 10,000 Confederate sick and wounded were brought to Newnan for treatment," according to Mathews. "The Female Benevolent Society still met, but it was different now," recalled Candler. "Now the talk was of bandages and lint for the poor soldiers, and the chief activity was scraping old linen table clothes for wound dressings."

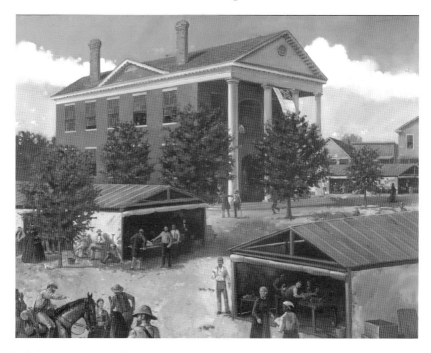

Martin Pate's rendering of the old Newnan Court Square when it served as a hospital site during the Civil War. Several one-hundred-foot-long sheds were constructed on the courthouse lawn to treat the wounded.

It wasn't until the morning of July 30, 1864, that the war arrived on Newnan's doorstep, however. Brigadier General Edward McCook had orders from General William T. Sherman to destroy railroad supply lines and communications south of Atlanta.[52] "Rumors of the approach of the Federal forces under McCook had for days disquieted our minds," said Fannie Beers, a nurse stationed at one of the Newnan hospitals at the time. "The little town of Newnan and immediately surrounding country was already full of refugees. Every day brought more."

Beers described the morning of the first skirmish in her journal. The previous night, a regiment of Confederate cavalry under General Phillip Roddey had taken up residence at the railroad depot, but it did not seem a cause for alarm. The reason for the impasse was that McCook's Union troops had successfully damaged the train rails in Palmetto, just north of Newnan. Roddey's cavalry was stuck until repairs could be made. This would prove unfortunate for McCook's retreating forces:

> *The following morning opened bright and lovely, bringing to the anxious watchers of the night before that sense of security which always comes with the light. All business was resumed as usual. I had finished my early rounds, fed my special cases, and was just entering the distributing room to send breakfast to the wards when a volley of musketry, quickly followed by another and another, startled the morning air. Quickly an excited crowd collected and rushed to the top of the hill commanding a view of the depot and railroad track. I ran with the rest. "The Yankees! the Yankees!" was the cry.[53]*

Another nurse, Kate Cumming, wrote in her diary:

> *While I was in the yard of the court-house, attending to the patients, I saw a man ride in haste to town and a crowd collect around him. We were informed he was a courier, and had brought news that the enemy were within six miles of the place. He was not through talking when the locomotive gave a most un-earthly whistle, and immediately we heard the firing of musketry…*
>
> *I never saw men run as all did. The crowd who had been around the courier dispersed in double-quick time. I hurried across the street to secure some money and little trinkets that the men had given me to take care of, thinking they would be more secure with me than themselves. On crossing, two or three shots whizzed past me.[54]*

"The firing continued for a few moments, then ceased," said Beers. "When the smoke cleared away, our own troops could be seen drawn up on the railroad and on the depot platform. The hill on the opposite side seemed to swarm with Yankees":

> *Evidently they had expected to surprise the town, but, finding themselves opposed by a force whose numbers they were unable to estimate, they hastily retreated up the hill. By that time a crowd of impetuous boys had armed themselves and were running down the hill on our side to join the Confederates....Those who remained were fully occupied in attending to the women and children.*[55]

Cumming said that she heard cheering and a great shout that the "Yankees were running!" One man told her as he was rushing by to take cover immediately, because Union troops were placing cannons and preparing to shell the town. "A lady offered General Roddey a blanket as he worked to get his horseless cavalry into some kind of order," Cumming wrote. "It was evident that the fight was only delayed," observed Beers. "An attack might be expected at any moment. An exodus from the town at once began."

"It was rumored that the enemy had surrounded the town and would likely fire upon it," said Cumming. "We all suffered much from suspense, as we had many wounded; and if there was a battle in town, they would fare worse than any others":

> *How I did hate to think about all the poor fellows lying so helpless, momentarily expecting a shell to be thrown in their midst. We had them all moved into the strongest buildings; the court-house was crowded, although every one said a cannon-ball could easily penetrate its walls. Roddy's men were drawn up in line of battle on one side of our hospital. The citizens sent baskets of provisions to the soldiers who were in battle array, and we sent them what we could.*[56]

"Already refugees from all parts of the adjacent country had begun to pour into and pass through, in endless procession and every conceivable and inconceivable style of conveyance, drawn by horses, mules, oxen, and even by a single steer or cow," said Beers:

> *Most of these were women and boys, though the faces of young children appeared here and there—as it were, "thrown in" among the*

"plunder"—looking pitifully weary and frightened, yet not so heart-broken who knew not where their journey was to end. Nor had they "where to lay their heads," some of them having left behind only the smoking ruins of a home....McCook, by his unparalleled cruelty, had made his name a horror.

The citizens simply stampeded....There was no time for deliberation. They could not move goods or chattels, only a few articles of clothing; no room for trunks and boxes. Every carriage, wagon, and cart was loaded down with human freight, every saddle-horse was in demand. All the negroes from the hospital as well as those belonging to the citizens were removed at once to a safe distance. These poor creatures were as much frightened as anybody and as glad to get away. Droves of cattle and sheep were driven out on the run, lowing and bleating their indignant remonstrance.

The ladies, wives of officers, attendants, etc. were...difficult to manage, for dread of the "Yankees," combined with the pain of parting with their husbands or friends, who would soon go into battle, distracted them. Fabulous prices were offered for means of conveyance. As fast as one was procured it was filled and crowded. At last, all were sent off except one two-horse buggy, which Dr. McAllister had held for his wife and myself, and which was driven by his own negro boy, Sam. Meantime, I had visited all the wards, for some of the patients were very near death, and all were in a state of great and injurious excitement. I did not for a moment pretend to withstand all their entreaties that I would remain with them, having already decided to do so....At last everybody was gone; intense quiet succeeded the scene of confusion. I was alone—left in charge. A crushing sense of responsibility fell upon my heart. The alarm had first been given about eight o'clock in the morning. By three the same afternoon, soldiers, citizens—all had disappeared.[57]

Major General Joseph Wheeler and his exhausted cavalry finally arrived in town in the middle of the night, following a seventy-mile march. Recent reinforcements put Wheeler's forces at 720 men. Even with the reinforcements, they would be outnumbered over three-to-one.[58] "At 12 a.m., Wheeler's cavalry was seen approaching the town," said Cumming. "O, how joyfully we hailed them! They came galloping in by two different roads; the enemy, in the meantime hearing of their approach, were retreating. They were hotly pursued, and when four miles from town came up with them, where they made a stand, and had quite a battle."

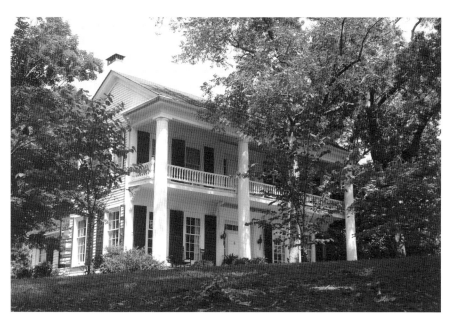

Buena Vista, at 87 LaGrange Street, just south of the railroad bridge marking the edge of downtown Newnan, functioned as Confederate general Joe Wheeler's temporary headquarters during the Battle of Brown's Mill.

Beers said:

> *The men had ridden far and fast. They now came to a halt in front of the hospital, but had no time to dismount, hungry and thirsty though they were. The regimental servants, however, came in search of water with dozens of canteens hung around them, rattling in such a manner as to show that they were quite empty. For the next half-hour, I believe, I had almost the strength of Samson. Rushing to the bakery, I loaded baskets with bread and handed them up to the soldier-boys to be passed along until emptied. I then poured all the milk I had into a large bucket, added a dipper, and threading in and out among the horses, ladled out dipperfuls until it was all gone. I then distributed about four buckets of water in the same way….Horses to the right of me, horses to the left of me, horses in front of me, snorted and pawed; but God gave strength and courage: I was not afraid.[59]*

The Union troops had proceeded along a "rickety backroad," heading around Newnan roughly on what is now called East Newnan Road and

Millard Farmer Road. The engagement occurred about three miles southwest of Newnan, at Brown's Mill, and lasted "more or less all day," wrote Corporal George W. Healey, Troop E, Fifth Iowa Cavalry, who won the Medal of Honor for his actions during the battle.

Wheeler split up his forces to prevent any further advance of McCook's troops. Two hundred engaged McCook's advance guard while Wheeler marched from Newnan with five hundred foot soldiers. "The fighting all along the line was terrific," said Major R. Root, Eighth Iowa.[60]

"In moving out we struck into low ground, timber, and heavy undergrowth," said Healey. "It was difficult to keep our alignment and intervals." Eventually, Healey came across "a body of Confederate soldiers." A "bareheaded" member of his company, Private Oscar Martin, whizzed past him in the opposite direction, announcing that the "woods are full of 'em."

Soon afterward, the wounded soldiers who remained at the hospital in downtown Newnan declared they "heard guns" in the distance. "I could not then detect the sound, but soon it grew louder and more sustained, and then we knew a battle was in progress," said Beers. "For hours the fight went on. We awaited the result in painful suspense."

"We heard the booming of cannon, it seemed to me, about two hours," said Cumming. "We eagerly listened to hear if it came nearer, as then we would know whether we were successful or not; but it did not seem to move from one spot. We...did not know what to expect."

Confederate lieutenant S.B. Barron, Third Texas Cavalry, Ross's Brigade, described his experience of the battle:

> *We were moved rapidly into the timber and ordered to dismount and fight....Almost immediately, we were ordered into line, and before we could be properly formed, were ordered to charge into through undergrowth so dense that we could only see a few paces in any direction....On we went in the charge, whooping and running, stooping and creeping, as best we could through the tangled brush. I had seen no enemy in our front, but supposed that they must be in the brush or beyond it. Lieutenant Sim Terrell of Company F and myself had got in advance of the regiment, as it was impossible to maintain a line in the brush, Terrell only a few paces to my right. Terrell was an ideal soldier, courageous, cool, and self-possessed in battle. Seeing him stop, I did likewise, casting my eyes to the front and there, less than twenty-five yards from me, stood a fine specimen of a Federal soldier behind a*

Black Jack Tree, some fifteen inches in diameter, with his seven shooting Spencer Rifle resting against the tree, cooly and deliberately taking aim at me. Only his face, right shoulder and part of his right breast were exposed. I could see his eyes and features plainly, and have always thought that I looked at least two feet down his gun barrel. As quick as thought, I threw up the carbine and fired at his face. He fired almost at the same instant and missed me. Of course, I missed him, as I expected I would, but my shot had the desired effect of diverting his aim, and it evidently saved my life.

Directly in front of Terrell was another man, whom Terrell shot in the arm with his pistol. The Federals both turned around and were in the act of retreating when two or three of Terrell's men came up and in less time than it takes to tell it, two dead bodies lay face downwards whereof, a moment before, two brave soldiers stood. I walked up to the one that had confronted me, examined his gun, and found he had fired his last cartridge at me. Somehow, I could not feel glad to see these two brave fellows killed. Their whole line had fallen back, demoralized by the racket we had made, while these two had bravely stood their post. I have often wondered what became of their remains, lying away out in the brush thickets, as it was not likely that their comrades ever looked after them. And did their friends and kindred at home ever learn their fate?

We moved forward in pursuit of the line of dismounted men we had charged, and came in sight of them only to see them retreating across the field. Returning to our horses, we saw them stampeding as Colonel Jim Brownlow with his regiment of East Tennesseans had gotten among them, appropriated a few of the best ones, stampeded some, while the rest remained as we had left them. We charged and drove them away from the horses and they charged us three times in succession in return, but each time were repulsed, though in these charges one or two of the best horses in the regiment were killed under Federal riders. These men were, however, only making a desperate effort to escape, and were endeavoring to break through our lines for that purpose, as by this time, General McCook's Command was surrounded and he had told his officers to get out as best they could. In consequence, his Army had become demoralized and badly scattered, and their ambulances, and all heavy baggage were abandoned, everything forgotten except the desire to return to their own lines.[61]

"About 4 p.m. word was brought that we had killed and captured the whole command," said Cumming. It was a complete rout, with 100 Federals killed or wounded and approximately 1,300 captured. Beers quickly made her way to the battlefield and described the scene:

The battlefield was not three miles away. I was soon tearing along the road at breakneck speed. At an improvised field hospital I met the doctor, who vainly tried to prepare me for the horrid spectacle I was about to witness....We turned into a ploughed field, thickly strewn with men and horses, many stone dead, some struggling in the agonies of death. The plaintive cries and awful struggles of the horses first impressed me. They were shot in every conceivable manner, showing shattered heads, broken and bleeding limbs, and protruding entrails. They would not yield quietly to death, but continually raised their heads or struggled half-way to their feet, uttering cries of pain, while their distorted eyes seemed to reveal their suffering and implore relief. I saw a soldier shoot one of these poor animals, and felt truly glad to know that his agony was at an end. The dead lay around us on every side, singly and in groups and piles; men and horses, in some cases, apparently inextricably mingled. Some lay as if peacefully sleeping; others, with open eyes, seemed to glare at any who bent above them. Two men lay as they had died, the "Blue" and "Gray" clasped in a fierce embrace. What had passed between them could never be known; but one was shot in the head, the throat of the other was partly torn away. It was awful to feel the conviction that unquenched hatred had embittered in the last moments of each. They seemed mere youths, and I thought sadly of the mothers, whose hearts would throb with equal anguish in a Northern and Southern home. In a corner of the field, supported by a pile of broken fence-rails, a soldier sat apparently beckoning to us. On approaching him we discovered that he was quite dead, although he sat upright, with open eyes and extended arm. Several badly wounded men had been laid under the shade of some bushes a little further on; our mission lay there. The portion of the field we crossed to reach this spot was in many places slippery with blood. The edge of my dress was red, my feet were wet with it. As we drew near the suffering men, piteous glances met our own. "Water! Water!" was the cry.[62]

"My hands, dress, and feet were bloody," wrote Beers, "and I felt sick with horror."

48

4

"A VERY CHEAP THING IN GEORGIA"

As the bloody war at last drew to a close, locals began to see ominous "signs" in the skies and even in the local flora—"dried blood," smells of death and giant swords, "edged in fire"—according to Myrtie Candler. "Our emotions had been strained for so long that the howl of a dog or the screech of an owl seemed to hold significance....Times were tense. Nerves were taut. The end was near." People began to run out of necessities, such as salt and coffee. The west side of the Newnan Court Square was "burned out" in 1864. Prices surged, making even everyday items like flour and butter unaffordable. "After the surrender we were left, for a time, with very little except land," Candler said. Many were reduced to thievery and begging, roaming from one burned and desolated town to another, taking what they could find just to survive. "The period of reconstruction was far worse than war times," said Candler. "There was no one to work the land, taxes were high…[and] sick and weary soldiers were passing through all the time, trying to get back to their homes." Candler's beloved pony, Bill, was stolen from the stable, replaced by some unknown soldier with a "pitifully exhausted old army mule." Atlanta had become a "city of chimneys, standing gaunt and naked like ghostly monuments to the houses that had once been there":

Conditions became very dangerous. Crime waves broke out. There was fear everywhere. Houses were burned, robberies occurred nightly. Still worse crimes were reported. It became dangerous to go out after dark. Pa had a walking stick that was very elegant looking. It had a heavy knob which he

held. Attached to this knob was a razor-sharp two-edged sword concealed in the hollow cane. If accosted by a robber he could strike at them with the cane. If the thug grabbed the stick to disarm him, it would unsheath the sword and leave Pa armed.

One night I was sleeping in my trundle bed beside my father's bed. Suddenly I awoke and saw a great giant of a brute squatting by the fireplace robbing my father's trousers. I reached up and jerked his covers and whispered "Pa!" He awakened and jumped out of bed unarmed. He shouted,

"Get out of here, you rascal! What do you mean!" The negro dropped the trousers and ran. Pa chased him off the place. Pa was now old and failing in health. The thug was young and powerful.

One morning while walking the mile to school (I walked to school now), I passed through a small clump of woods along the route and was congealed with terror to see placards on the trees written in red:

"THE DEAD OF CHICAMAUGA ARE HUNGRY FOR BLOOD. PREPARE, RADICAL, FOR YOU MUST DIE.

K.K.K."

I was frightened almost to death. I believed the signs were written in blood and put there by supernatural power. I ran choking and sobbing all the way to school, almost falling at every step. Ever afterward, throughout my childhood, I was afraid to pass through that wood alone.[63]

Captain M.B. Sloan, who was stationed in Newnan during Reconstruction, reported that there was "an average of one death a day among the freed men."[64] "Previous to the war the negroes belonged to the same churches to which the whites belonged," it was noted in the *Chronicles*, "but after they were freed both races concluded that it would be best to have separate churches."[65] Schoolhouses were also established separately. "Every church and school house for the negroes has had gifts from their white friends. What riots and clashes have occurred, came from the lawless and irreligious of the races and not from the Christians."

One such "riot" that caused a great stir when it appeared in the *Newnan Herald* on January 20, 1866, occurred in Newberry, South Carolina—a place with many Coweta County connections, as many of the Coweta settlers came from there. "We have learned from Judge R.Y. Brown the particulars

Pictured here is the original location of the Confederate memorial marker, at the intersection of Jefferson and Washington Streets. The monument, at a height of twenty-two feet and weighing sixteen tons, was one of many erected throughout the South at the time to honor the Confederate dead.

of the attempted murder of James Cureton living in Newberry District, South Carolina, but formerly a citizen of this county," reported the *Newnan Herald.* "About 10 o'clock at night of the 25th December a party of twenty-five armed negroes went to his home. Some broke down the door, while the outsiders fired at him through the window." "A slave warned them that the negroes were planning an insurrection," according to the *Chronicles,* "but the warning went unheeded."[66]

From the sensationalized *Herald* account:

> *So near were they that his clothes were set on fire. Two balls passed through his body, one through his left lung. Afterwards, he was beaten by the villains and left for dead. His son was also severely wounded. The object of the outlaws was nothing but murder of the whites. They had no special spite at Mr. Cureton....The negroes were all armed with Enfield rifles. Seven of the scoundrels have been apprehended and are now in Newbury jail. Dave, formerly a slave of James Harris, late of this county, was the leader and is one of the seven.*

Would it not be well for our citizens to be on the alert as thefts are frequent and outrageous acts such as described above may be perpetrated at any time?[67]

An account from the Newberry newspaper noted that "the negroes had been free less than a year," and "there was no civil law in South Carolina and the administration of justice was in the hands of Yankee garrisons":

The garrison stationed at Newberry was composed of as thorough a gang of scoundrels as ever wore white skins. They had undoubtedly filled the negroes' minds with the notion of killing off the white men and taking possession of the country, as some of the negroes afterwards confessed, and had supplied them with guns and ammunition with the admonition to "return them before daylight."

The Curetons soon made their way back to Coweta County and delivered their own firsthand accounts of the attack. Suspicions were aroused to such an extent that seemingly every crime was now being attributed to an ex-slave. The next month, the *Herald* reported the "stables and barn of Mr. Parks Fleming of this county were burned. Ben, formerly a slave of Mr. Fleming, was arrested. He confessed, saying he and Dick, formerly a slave of Mr. J.E. Dent, hoped to attract attention of Mr. Fleming and family while they entered the smoke house to remove bacon." In August, a burglary was reported by a Martin Hubbard, and he pointed to one of his former slaves as the culprit. At the same time, there were also notices in the newspaper pointing to the "courageous conduct of the negroes," such as when the Coweta Hotel caught fire and damaged much of the town. The former slaves' "interest in the welfare of the whites was truly noble," the *Herald* reported.

Some blacks were elected to public office during the time period immediately following the war, causing tensions with the white community. Following a local murder, "the negro coroner came down to Puckett Station (Moreland) and summoned a jury," according to the *Chronicles*. A white judge, H.W. Camp, was selected to serve, "and his docile compliance with the [black] official's orders occasioned many jibes at his expense, and flaming indignation from some of his younger brothers."[68]

With the numbers of blacks and whites in Newnan and Coweta County at roughly equal levels, a struggle for social dominance was occurring, both locally and throughout the South. "The county was greatly wrought up

when the Republicans nominated Sam Smith, a negro, to run with Captain Sargent on their ticket for the Legislature," reported the *Chronicles*. Though the white southern Democrats "picked good men and true, they lost the election, the number of negro voters was about equal to the white voters."[69]

In Hogansville, just south of the Coweta County line, whites openly revolted when the U.S. government appointed Isaiah H. Loftin, a black man, as postmaster. "It is the United States government against the town of Hogansville," a report in the February 11, 1898 *Newnan Herald and Advertiser* stated. The post office was "completely ignored" by the white population, the report stated. The whites considered the appointment of a black man to such a prominent position a "farce." In a rare move at the time, Loftin was asked his thoughts on the matter, and surprisingly his words were reported without the offensive *patois* so commonly employed to demean blacks during this era: "Of course, it is not pleasant to live in a town where the people do not treat you with respect."[70]

These tensions and resentments gave rise to outlaw groups such as the Ku Klux Klan, accompanied by mob violence and—all too often—public lynching. Systematic oppression, later enforced through what became known as "Jim Crow" laws, discouraged blacks from voting, going to school or working at all, except for the most menial jobs. "My, first and only teacher was a Mr. Standard, who taught school in Newnan, Ga. I was sent to him after de war. But I had to leave and go to work before I learned much," said Morgan Ray. He continued:

> I've generally kept out of trouble by keepin' my mouf shet and doin' what I though was right. Take votin' fer instance. De boss man on de different farms where I worked would tell me around election time to vote Democratic. But I knew de Republican party wuz on de side of de cullud man. So I nevah say nothin' when de boss man told me how to vote. I nevah promised anything at all. I just went to de polls on election day and put my cross under de eagle.
>
> Course I didn't get much chance to vote in my younger days. You know how it is in a lot of dem southern states. A cullud man who ain't got so much property and can't read de Constitution of de United States ain't allowed to vote. I think dat system is very bad....I members when cullud men elected to Congress wuz warned not to go to Washington and take office…
>
> De Klu Klux, I done heard after I wuz free, wuz organized to make bad niggahs behave. I warn't afraid of 'em 'cause I was a pretty good boy and minded my own business. I heard a lot about the Klu Klux, but it warn't till

*long afterwards dat I evah see 'em. It was one night after de work of de day
was done and I was takin' a walk near where I worked. Suddenly I hear
the hoof beats of horses and I natcherly wuz curious and waited beside de
road to see what was comin'. I saw a company of men hooded and wearin'
what looked like sheets. Dey had a young cullud man as dere prisoner. I wuz
too skairt to say anything or ask any questions. I just went on my sweet way.
Later I found out dey acclaimed de prisoner had assaulted a white woman.
Dey strung him up when he wouldn't confess, and shot him full of holes
and threw his body in de pond.* [71]

One of the most outspoken opponents of lynching and other forms of mob
violence was a young Newnan attorney: William Yates Atkinson. A native of
Meriwether County, Atkinson moved to Newnan to establish his law practice
after graduating from the University of Georgia law school in 1877. Two
years later, he was appointed solicitor of the local court, and by the 1880s,
he was elected Coweta County's representative to the Georgia General
Assembly, with which he served four terms, eventually becoming Speaker of
the House. A proponent of public education, he authored the bill creating
the Georgia Normal and Industrial School for women (now Georgia College
and State University) at Milledgeville. He became Georgia governor before
he was forty—in 1894—beating a "popular and distinguished Confederate
soldier who was supported by every daily newspaper of prominence in the
State and backed by the influence of nearly all the old and tried political
leaders," reported the *Herald*.

At the beginning of his second term, noting that twenty-two lynchings
had occurred in Georgia in the previous three years, Atkinson made
vigilantism a centerpiece of his inaugural address, calling it "treason"
against the government:

*The frequency of such occurrences within the last few years is calculated to
alarm every citizen who realizes the dreadful results to which it leads, or the
enormity of the crime against human rights, government and civilization.
To denominate these offenses of lynchings do not make them less lawless
or barbarous.*

*It is an attack upon government itself—a conflict between the forces of
anarchy and law. It is fundamentally wrong, because it defies government,
ignores law and punishes without law or evidence…*

*In a free government like ours there is no excuse for lynching. If there
is evidence to convict the courts will punish; if there is not, punishment*

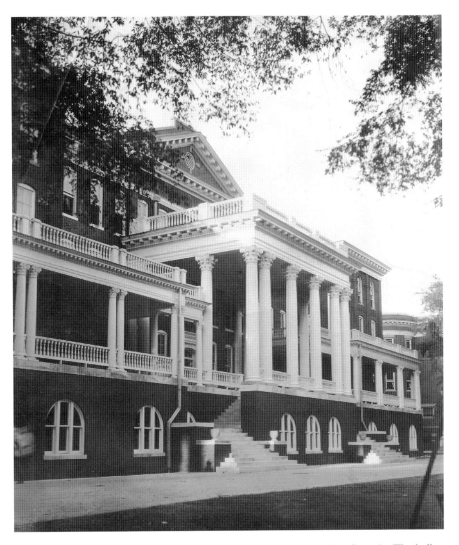

Atkinson Hall at Georgia College and State University in Milledgeville, Georgia. The hall was named in honor of Governor Atkinson, who authored the legislation to establish the college, formerly a school for women.

should not be inflicted. The courts of our State can be trusted to punish the guilty and protect our property, our persons, and the honor and virtue of our women.

I am deeply concerned for a remedy for this evil that we may save from guilt the men who engage in it, and protect the innocent, who are too often sacrificed.

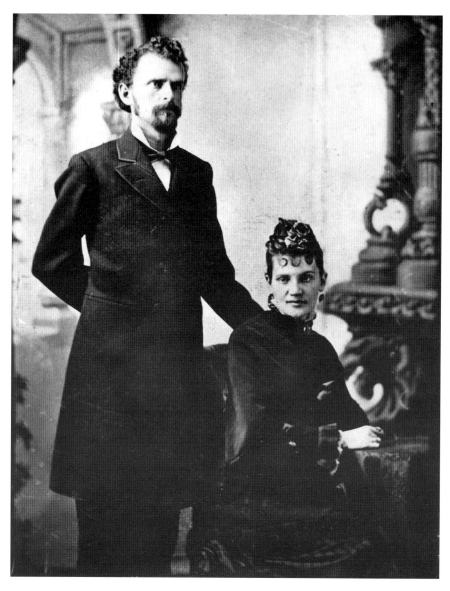

Newnan attorney William Yates Atkinson was governor of Georgia for two two-year terms, from 1894 to 1898. He was known as a reformer, hiring the first female salaried employee at the state capitol. He was also an outspoken opponent of lynching. Atkinson is pictured here with his wife, Susan Cobb Milton Atkinson.

The mob is not a safe tribunal to justly determine any cause…

The mob judges without a full and complete hearing from both sides. Its members are not the most capable of judging. It decides in passion and too often in whisky. How can it fail to make mistakes and sacrifice the lives of the innocent?

I feel the more deeply upon this question because from the best information I can secure, I believe that during my administration there have been in this State several men lynched who were not guilty of the crimes with which they were charged. How many, can never be known, for their tongues are hushed. and they are denied an opportunity to prove their innocence. I am informed one man, whom the mob believed to be guilty, was shot down. A question then arose as to his identity and he was salted down like a hog, shipped to the location of the crime and found to be the wrong man—an innocent man.

When an innocent man is lynched for a crime it serves to protect the guilty. The members of the mob, their friends, and sympathizers seek to impress it upon the community that the right one has been punished and the guilty goes unsought and unsuspected. Even during this year evidence has come to light showing that in several States victims of the mob have been innocent men…

Responsibility for the crime of lynching rests not only upon actors, but upon the community which shuts its eyes to the crime and permits and tolerates it, and upon legislators who refuse to enact laws to suppress it. It can and will be stopped when the better element, who depreciate mob law, aggressively condemn and determine to suppress the practice…

Even had it been confined to offenses committed upon females, it could not be justified.

To adopt it in these cases, is to put the life of every man in the power of any woman who might for any reason desire his death. When such crimes are charged the passion of the people is more deeply stirred than by any other, and the mob is quick to act.

Yet viewed from the standpoint of reason and not of passion, there is less excuse for lynching in such cases than in any other. Delay cannot be given as a reason, nor a fear that justice will be defeated…it is a defiance of law. It is a desire to Substitute passion for evidence and vengeance for Justice.

There is…no justification nor excuse for a resort to lynching, even…when the defendant is charged with the most dastardly and horrible of crimes. No man doubts in these cases that the law will punish the guilty, and if he did, he could not find a remedy by making a murderer of himself. The remarkable fact exists that in a majority of instances the party lynched is

taken from the custody of officers. I can understand how a near relative of the victim of the lust of a human brute, who sees before him the man whom he believes has committed the outrage, and in the heat of passion slays him, can enlist the interest and sympathy of a community: but how any one can fail to condemn those who are guilty of the cowardly act of taking from the officers of the law a man who is disarmed and helpless, and hanging him without trial, surpasses my comprehension…

The frequent occurrences of lynching will advertise ours as a lawless State and as a half-civilized people.

It sacrifices the innocent, brings law into disrepute, creates lawlessness, impedes material growth, and in the eyes of all the world lowers the standard of our civilization and degrades the character of our people…

I condemn it….To exterminate the practice it must be made odious and dangerous. The penalty should be the scorn of the people and the punishment of the law.[72]

Atkinson did what he could while in office, sending troops to defend some who were in danger of being lynched by mobs and even pardoning an innocent black man, Adolphus Duncan, who had twice been falsely convicted and sentenced to death for the rape of a white woman. Many of Atkinson's opponents accused him of pandering to the black voters. One particularly virulent piece of campaign literature alluded to "Atkinson's Secret Circular to the Colored Voters of Georgia," wherein Atkinson's critics said his pardon of Duncan was done solely to appeal to the black vote, while ostensibly putting white women in danger. It was "past belief that any man could be so consumed with a hunger for office as to be willing to arouse the beastliest passions of the vile, and expose the pure Womanhood of his state to fearful danger by posing as the champion of beastly brutes," Atkinson's critics wrote. "This is a piece of infamy that must boil the blood of any respectable Southern man."[73]

One way of ensuring politicians like Atkinson did not try to appeal to black voters was to eliminate them from the voter rolls altogether. At the turn of the century, with Reconstruction long concluded, southern states began working to do just that. A January 27, 1899 edition of the *Newnan Herald and Advertiser* touted on the front page a proposed North Carolina bill "having for its purpose the practical elimination of the negro as a voter." The bill had much to recommend it, the newspaper reported, and had been "modeled after the Louisiana law, which embodies both a property and an educational qualification." North Carolina expected the

new legislation to disenfranchise as much as 80 percent of the African American voting population.[74]

Racist images of the happy, servile, ignorant, childlike slave of the antebellum era had by now been replaced by newly minted racist images of the cunning, beastly, rapacious, predatory Negro. A February 3, 1899 edition of the *Newnan Herald and Advertiser*, for instance, ran a report from a trial in Macon of a black man named Luther Shields who, when given a fifteen-year sentence by the court for burglary, "remarked with a sneer, 'Is that the best you can do?'" When the judge doubled his sentence, "the negro was led away, smiling," the report said.[75] While the earlier stereotype had served the first generation of white planters, the new grotesqueries depicting savage men always on the edge of violence were better suited to instilling fear and suspicion in the white populace, giving license to the power brokers who wished to ensure continued white supremacy in politics and social life and "purity" of the white race through rigid class structures, even if that meant adopting new laws prohibiting intermingling of the races and rolling back hard-won civil liberties. Paving the way for such actions was the so-called Atlanta Compromise, brokered by Booker T. Washington at the 1895 Atlanta Exposition. Under the new agreement, blacks would assent to white political rule in exchange for basic education and protection under the law. Blacks would no longer work to attain true equality or integration. Under such conditions, facing such defeat on the heels of such early promise, would it be any wonder if resentments began to fester among blacks in local communities?

Eventually, these tensions led to a series of literal conflagrations in the town of Palmetto, on the northern Coweta-Campbell County boundary. The first fire struck in late January 1899, originating in Paul Peniston's drugstore and quickly spreading to adjoining buildings.[76] The February 3 edition of the *Newnan Herald and Advertiser* reported that "our sister town, Palmetto, has again been ravaged by fire, making the second disaster of the kind within a week." This was undoubtedly the work of an arsonist, as "traces of kerosene oil and a lot [of] kindling piled against the door" were found. Almost none of the extensive losses to local merchants was covered by insurance. "The citizens of Palmetto are thoroughly wrought up, and have determined to leave no means untried" to bring the arsonists to justice, the newspaper reported.[77]

Rumors swirled of a "Negro conspiracy"—perhaps cultivated by outsiders from Atlanta and elsewhere—to get revenge against local whites. The tensions boiled over on March 16, 1899, following the arrest of nine black

suspects. A highly sensationalized report in the Atlanta newspaper tells of the mob scene that followed, during which four of the black prisoners were killed. The mob of "100 desperate men," wearing masks, bolted into town, armed with "Winchesters and shotguns and pistols," the newspaper reported. Guards at the makeshift jail were quickly dispatched, and the suspects were "tied together with ropes." The men were described as "trembling, pleading, terror-stricken…begging for life and declaring that they were innocent."

The account continued:

> "Oh, God, have mercy!" cried one of the men in his agony. "Oh, give me a minute to live."
>
> The cry for mercy and the prayer for life brought an oath from the leader and derisive laughter from the mob…
>
> "Burn the devils," came a suggestion from the crowd.
>
> "No, we'll shoot 'em like dogs," said the mob's leader…
>
> They stood, trembling wretches, jerking at the long ropes that held them by the waist and about the wrists.
>
> "Oh, give me a minute longer!" implored Bud Cotton.
>
> "My men, are you ready?" asked the captain, still cool and composed and fearfully determined to execute the bloodiest deed that has ever stained Campbell County.
>
> "Ready," came the unanimous response.
>
> "One, two, three—fire!" was the command, given orderly, but hurriedly.
>
> Every man in the room, and the number is estimated at from seventy-five to one hundred and fifty, fired point blank at the line of trembling and terror-stricken bound wretches.
>
> The volley came as the fire from a gatling gun.
>
> It filled the warehouse with smoke and flame and death and brought a wail of horror that chilled the helpless guard…
>
> The men jerked the fallen, twisting and writhing and bleeding bodies about.
>
> The first man they reached was not dead. He was still groaning, and the breath was coming in great, quick gasps.
>
> A pistol was placed at his breast and every chamber was emptied.
>
> "He's dead now," laughed one of the crowd.

The newspaper reported that "the Negro population of Palmetto has fled from town." The writer said that locals believed they were "congregating on the outskirts and will make an assault upon the town to-night." Such an attack never came and, of course, was never imminent. Even if many local

blacks still could not read, they knew well the threatening truth of what the newspaper reported: "The lives and property of citizens will be protected at any cost and the white people, while condemning the act of lawlessness of the mob, are determined to meet any attempt the Negroes may make for revenge."[78]

Less than a month later, just south of Palmetto, on the Coweta County farm of Alfred Cranford, an even more sensational racially charged incident occurred. This event captured media attention across the Eastern Seaboard. As the *Chronicles* later described it, "Newnan was given undeserved and undesired nation-wide publicity when a mob brought Sam Hose, caught at Griffin, Georgia after one of the most fiendish and horrifying crimes at Palmetto in the annals of the State, to one of her suburbs and burned him." This single sentence is the only mention in local history books of what is undoubtedly one of the most horrifying lynchings ever perpetrated.[79]

A farmhand from Macon County referred to variously as "Sam Hose" and "Sam Holt"—but whose real name was apparently Tom Wilkes—got into a heated argument with Cranford. The details of the incident are still debated, but Hose "no doubt" killed Cranford with an axe, an independent investigator concluded at the time. (Hose was also accused of raping

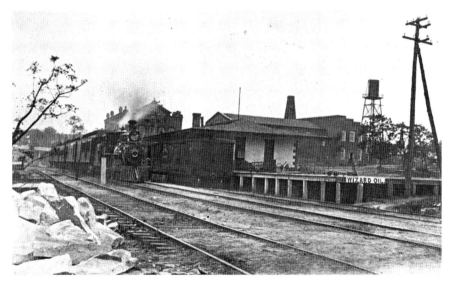

This photo of the Newnan Depot, serving the Atlanta & West Point Railroad, was taken in the decade prior to the lynching of Sam Hose. Hose arrived on a train in 1899 and was delivered to the jail for a reward claim prior to being taken by a mob and paraded around the town.

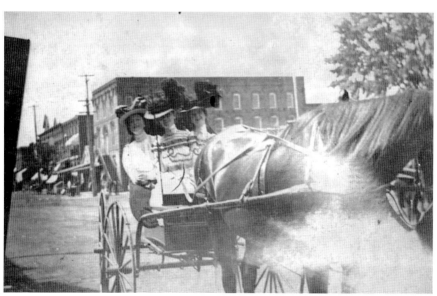

Above: Newnan streets prior to paving, late 1800s. The couple is wearing Victorian-era clothing.

Opposite, top: A rare shot of the old (original) Coweta Courthouse, looking south. The voters of Coweta County elected to keep the courthouse, but the commissioners decided to tear it down, anyway. A new courthouse was constructed in 1904.

Opposite, bottom: A trio of young ladies enjoy a buggy ride through downtown Newnan in 1889. This photo was taken on the east side of the Court Square, in front of the original courthouse.

Cranford's wife and injuring his small child, but some have argued that these were inflammatory allegations intended to stir up the passions of the local white residents.) Rewards were offered by area newspapers and law enforcement agencies, and a statewide manhunt, fueled by a series of highly sensationalized newspaper headlines, resulted in Hose's quick apprehension. After he was put into custody and sent by train back to Newnan, things quickly went awry. Hose was seized from the jail by a mob, paraded around the Court Square and marched up what is now Highway 29, to a wooded

area just across from the road from where Sprayberry's Barbecue is now located. As the newspapers reported:

Sam Hose, the Negro murderer of Alfred Cranford and the assailant of Cranford's wife, was burned at the stake one mile and a quarter from this place this afternoon at 2:30 o'clock.

Fully 2,000 people surrounded the small sapling to which he was fastened and watched the flames eat away his flesh, saw his body mutilated by knives and witnessed the contortions of his body in his extreme agony.

Such suffering has seldom been witnessed, and through it all the Negro uttered hardly a cry. During the contortions of his body several blood vessels bursted. The spot selected was an ideal one for such an affair, and the stake was in full view of those who stood about and with unfeigned satisfaction saw the Negro meet his death and saw him tortured before the flames killed him.

A few smoldering ashes scattered about the place, a blackened stake, are all that is left to tell the story. Not even the bones of the Negro were left in the place, but were eagerly snatched by a crowd of people drawn here from all directions, who almost fought over the burning body of the man, carving it with knives and seeking souvenirs of the occurrence.

Preparations for the execution were not necessarily elaborate, and it required only a few minutes to arrange to make Sam Hose pay the penalty of his crime. To the sapling Sam Hose was tied, and he watched the cool, determined men who went about arranging to burn him.

First he was made to remove his clothing, and when the flames began to eat into his body it was almost nude. Before the fire was lighted his left ear was severed from his body. Then his right ear was cut away.

During this proceeding he uttered not a groan. Other portions of his body were mutilated by the knives of those who gathered about him, but he was not wounded to such an extent that he was not fully conscious and could feel the excruciating pain. Oil was poured over the wood that was placed about him and this was ignited.

The scene that followed is one that never will be forgotten by those who saw it, and while Sam Hose writhed and performed contortions in his agony, many of those present turned away from the sickening sight, and others could hardly look at it. Not a sound but the crackling of the flames broke the stillness of the place, and the situation grew more sickening as it proceeded.

The stake bent under the strains of the Negro in his agony and his sufferings cannot be described, although he uttered not a sound. After his ears had been cut off he was asked about the crime, and then it was he made a full confession. At one juncture, before the flames had begun to get in their work well, the fastenings that held him to the stake broke and he fell forward partially out of the fire.

He writhed in agony and his sufferings can be imagined when it is said that several blood vessels burst during the contortions of his body. When he fell from the stake he was kicked back and the flames renewed.

Then it was that the flames consumed his body and in a few minutes only a few bones and a small part of the body was all that was left of Sam Hose.

One of the most sickening sights of the day was the eagerness with which the people grabbed after souvenirs, and they almost fought over the ashes of the dead criminal. Large pieces of his flesh were carried away, and persons were seen walking through the streets carrying bones in their hands.

When all the larger bones, together with the flesh, had been carried away by the early comers, others scraped in the ashes, and for a great length of time a crowd was about the place scraping in the ashes. Not even the stake to which the Negro was tied when burned was left, but it was promptly chopped down and carried away as the largest souvenir of the burning.[80]

Alleged Hose accomplice Elijah Strickland, a local preacher, was strangled and lynched on April 23, and a note was attached to his body: "Beware all darkies. You will be treated the same way."

When one examines the details of these lynchings, painstakingly reported in macabre detail in one media outlet after another to gratify the readers, one realizes that these events were not intended to serve simply as punishments. Rather, a participatory public spectacle such as the Sam Hose lynching was a ritualized performance, a kind of twisted communion and, above all, a demonstration of white power.

"The real purpose of these savage demonstrations is to teach the Negro that in the South he has no rights that the law will enforce," said northern black activist Ida B. Wells. "Samuel Hose was burned to teach the Negroes that no matter what a white man does to them, they must not resist."[81]

Former governor William Atkinson, just a few months removed from office, intercepted the crowd in his buggy just before the Hose lynching. Even though he was in poor health—and would die just months later—he faced down the mob and pleaded with them not to commit this crime. "The

law will take its course," said Atkinson. "And I promise you it will do so quickly and effectively. Do not stain the honor of this State with a crime such as you are about to perform." Atkinson was shouted down, and a gun was leveled at him. Another local attorney, Alvan Freeman, was likewise forced to relent.

On seeing Hose's charred knuckles on display in an Atlanta shop window, black activist and intellectual W.E.B. Du Bois called off a scheduled meeting with newspaper editor Joel Chandler Harris (who had made his fame and fortune appropriating black folk tales he'd heard as a child and repackaging them under the guise of "Uncle Remus"). This meeting, Du Bois decided, would be of no use.

A private detective hired to investigate the Sam Hose lynching concluded his report thus: "I made my way home thoroughly convinced that a Negro's life is a very cheap thing in Georgia."[82]

5

"I LIKE TO KILL MY HAM LIKE I LIKE THEM"

Pa and his friends talked in low voices these days and were troubled: "Widows and orphans of soldiers reported in want;" "Poor people starving." None of us had any money and the needy could not wait.

One day an old couple came stumbling up the road and asked for shelter. They told us their house had been burned and they had escaped with only the clothes they were wearing which were filthy and torn. They had come a long way and had been sleeping in the woods without food. Pa was not at home but we children made them a bed in the barn, and we carried to them such food as we had. The old man jumped up and down in a frenzy. He screamed, "Can't you see we are starving! My Old Lady's sick. She has had nothing to eat for days but creek-water. We need soup and milk and sick folk's vittles!" He threw the food at us. He was beside himself with anger and despair.[83]
—Myrtie Long Candler

Following the Civil War, many formerly prosperous local farmers suffered dislocation, impoverishment and exploitation. Many who had previously owned their own farms were forced to work as sharecroppers, a system allowing a tenant to farm acreage in exchange for a share of the yield.

"My father was a farmer. This farm around where Ruth Hill School is now and all of the area in there, that was my father's farm," recalled Katie Freeman Thompson, born in 1917. "He was what you'd call a sharecropper. A group of men owned a certain amount of land, and they would get people to live on the farm in a house and farm that land." Sharecroppers were both

white and black, but the landowners were almost always white, Thompson said in an oral history interview.[84]

"The owners provided the house," she said, and the landowner usually provided the mules and basic equipment. "And mostly the person who was using the land, they had their own livestock....My father grew hogs for meat. We had chickens, you know, my father did, and we raised chickens for eggs and to eat, and we had cows for milk and butter. And we raised cotton and corn. Cotton, especially. A certain percentage would go to the land company."

"In the fall, my husband used to say, we 'settled up'" with the sharecroppers renting the land, remembered Mary Fox North Slaughter of Sharpsburg, in southeast Coweta County.[85] "We had a big farm, a fifty-acre farm, so we would have a man, we would get somebody and they would move into that house, you see....They didn't have any way of making a living. They had to have something....That's how it came about. And sometimes they would be white, all white. And sometimes it would be the other way. Back in those days there were some good farm people who were black."

Slaughter was from one of the pioneer Sharpsburg families, and they were always landowners, she said. In fact, the Norths were descendants of English royalty, Slaughter said in her oral history. "My great-grandfather was one of the Lord Norths of England, all right? We got all that worked out," she said. "Then three of the descendants came to America, to Richmond, Virginia...that was my folks. And after a while they decided they would settle here in Sharpsburg."

She said her parents always had sharecroppers working the farm for them when she was growing up in the early twentieth century.

"Mama and daddy had a farm, and they always had someone living on it," she said. "They always had that. And besides that, my father would do stuff, too. There were things he could do."

But sharecropping was the only way many people could make a living, she said.

"My daddy would give the sharecroppers I don't know whether it was fifty or seventy-five dollars, he would give them the whole check," she said. "And they would live off that" and buy the supplies they needed for the farm for that season. Sometimes loans were given when emergencies came up, and that was added to the total.

"We got somebody in our farmhouse, and well, they would need some money. And they would send one of their children," said Slaughter. "I remember this one particular time a teenager came to our house and said,

'Mama said would you let her have fifty dollars.' And we did, because they were gonna pay it back….We helped each other."

After the crops came in and were accounted for, generally around October, the landowner and sharecropper would have a meeting during which they would "settle up" what was owed, she said.

"I remember once I went upstairs, and my husband and this man, a sharecropper, were settling up, and I heard them talking, and that man said my husband was a good one to share for, that they never did have any trouble," Slaughter said. "And we got what they owed us, and they got what we owed them."

In those times, Slaughter said, "farming wasn't much." Families "never did make much from farming."

Ollie Louise Evans of the St. Charles community—between Moreland and Grantville in southern Coweta County—remembered in an oral history that around the time of the Great Depression, farmers would often barter for goods at the local general store, owned by John Morris.

"We would barter for salt, sugar, coffee and Father's tobacco that used to come in a pretty cedar box," said Evans. "Sugar came in sacks with these big, white letters, and Mama would soak those sugar sacks in lye soap to get the print out and she would use them to make our underpants….Times were hard back then, and people didn't have money.

"But Mr. Johnny would let you barter," said Evans. "You could take eggs up there and buy staple goods, buy groceries. He'd take an egg for a stamp. Eggs were twenty-five cents a dozen, so you would just hand him an egg and say, 'Would you mail this, Mr. Johnny?'"[86]

James Mansour, whose father was a Lebanese immigrant who opened a prominent store on the Newnan Court Square at the turn of the century, said that, even in downtown, bartering was not uncommon.

"During the Depression, people didn't have any money, and they would come in and bring eggs and vegetables and even chickens," said Mansour. "My job as a boy was to get some old suitcase and cut holes in it and put those chickens in there. They would trade it in. And we would eat 'em. We'd take those chickens home and kill them and eat them."[87]

Sometimes having to barter could be embarrassing, remembered Evans.

"When I was in junior high school, I went in there to Mr. Johnny's store, and there was a nice young man standing there talking to Mr. Johnny, and I handed him an egg and the letter, and I says, 'Mail this for me, would you, Mr. Johnny.' He said, 'I'll put a stamp on it right now.' And that well-dressed man just busted out laughing. He thought it was funny, and maybe it was

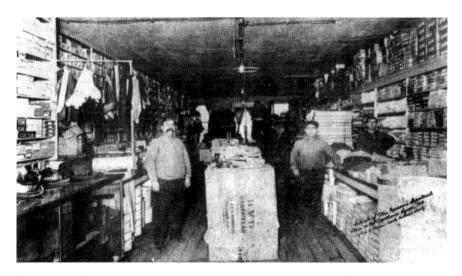

The Mansour family, Lebanese immigrants, operated businesses on the Newnan Court Square for over a century. This photo shows the interior of their original Perry Street location in 1911. From left to right are Ellis Mansour, Michael Mansour and Nasor Mansour.

Mary Fox North Slaughter of Sharpsburg, Georgia, claimed to be descended from English royalty. She recalled many instances of "settling up" with sharecroppers on her property.

funny to somebody else. He was from one of the more prominent families in Newnan. I was old enough to be embarrassed. I never would take another egg. I made my little sister do it."

Evans remembers her father and other local farmers growing peanuts, sweet potatoes, corn and especially cotton, which would be ginned locally to remove the seeds before going to the mill.

"There was a cotton gin in Moreland. It was a big gin," said Evans. "I remember looking out the window at my school and there would be wagons as far as you could see down the road. People would be standing in line. They were piled high. A two-horse wagon would hold five hundred pounds of cotton."

Farmers would often get conflicting messages when it came to making a cotton crop. For instance, while one fertilizer ad in a January 1899 edition of the *Newnan Herald and Advertiser* boasted that cotton "is and will continue to be THE money crop of the South" and urged farmers to "get the most cotton from a given area at the least cost," a news article on the same page reported that the South was "being crushed under the vastness of her cotton production." Thousands of bales of local cotton would "rot in the field" due to low prices, the newspaper predicted. In an awful economic loop, "poverty compels people to go in rags," decreasing the demand for cotton goods, all but guaranteeing low prices for farmers, sustaining the downward spiral. "Sensible men will not desire to continue that sort of a system," said the report.

But continue it did, leading to the slow death of many local farms. Evans recalled that her grandfather was literally killed bringing cotton into town in 1910.

"He lived between Moreland and Grantville, and he came by the house in St. Charles, wanting to pick up Raymond, his oldest grandchild, to go to the gin with him," said Evans. "He put his bale of cotton in the wagon, and then at the last minute my parents got worried Raymond might get hurt. He was four years old. So he didn't go." Just as he got to the railroad crossing, a train approached, but her grandfather didn't see it or hear the whistle. "They hollered, 'Mr. Bill! You can't make it! And grandpa didn't hear it," she said. "The train hit him, and his two mules died instantly. They took him and put him in the depot at Moreland, to get him out of the weather. And that's where he died." Raymond later received the train's whistle as a gift, she said.

As enterprising farmers looked for new ways to beat the system and get as much cotton to the gins as quickly as possible, for the least cost, locals were

treated to cartoonish sights of impossibly overstuffed wagons, as reported in the *Newnan Herald and Advertiser* in 1903:

> *The most novel sight of its kind ever witnessed in Newnan was an immense wagon that came in last Saturday morning from Hon. S.E. Leigh's farm loaded with cotton. Twenty-five bales were on the wagon, and three yoke of oxen were required to pull the load, the gross weight of which was 20,607 pounds. The cotton weighed 13,140 pounds and was bought by A.R. Burdett & Co. at 9½ c., who gave their check for $1,228.15 in payment for the lot. Mr. Leigh had the wagon made to order and it is without doubt the strongest and heaviest road vehicle in the county. It cost $75.*[88]

Eventually, Ollie Evans took a job with the government in agricultural conservation, and she "paid the farmers not to plant so much cotton." "We had to measure the cotton fields and pay the farmers so much an acre for not planting it. I had to use a spyglass sometimes, and it was hard on my eyes."

"Cotton was cheap, you see, and there were little ol' cotton patches everywhere, wherever you could put it," recalled Frank "Bo" Barron. "And then the boll weevil came and ate up everything."[89]

While the Manget Brothers Store advertised "Death to the Boll Weevil" by using "Hill's mixture, made of arsenate, molasses and a secret ingredient," local farms were forced to hire extra help and plant smaller plots to allow for the application of the new weevil control tactics by hand.

The E.N. Camp Company was perhaps one of the biggest casualties of the cotton bust in that part of the county. "Mr. Camp bought and sold cotton, and he was a millionaire," said Evans. During the company's height around the time of World War I, it employed one hundred men and was composed of thirteen buildings in Moreland. The company manufactured "plows, stalk cutters, land rollers, and their famous cottonseed planter and guano distributor by the thousands," according to the *History of Coweta County, Georgia*.[90] "He could write a check, and it would be honored anywhere in the United States. He had a store and the bank and the land," said Evans. "And when cotton prices went down, the day after it dropped, he didn't have fifteen cents to his name. He didn't have a thing left. He died without anything."

She remembered that her mother got word that the bank, closely associated with Camp Manufacturing, "was fixing to fail," in 1926. "Mama was the secretary-treasurer of the Moreland PTA, and she sent my oldest

Ollie Louise Evans of the St. Charles community in southern Coweta County. Her home was at 4000 South Highway 29. She was eighty-five at the time of her interview.

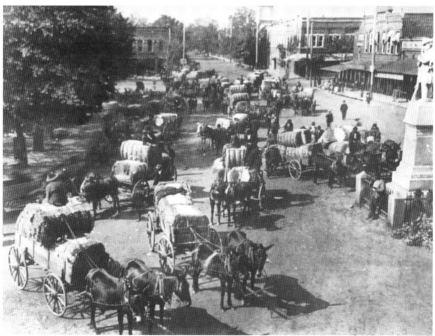

Cotton day on the North Court Square in Newnan. A postcard bearing this image is inscribed, "Dear Mother, this is some cotton country, all you can see is cotton."

brother down there to get what was left of the PTA money," said Evans. "And there was only thirteen cents left."

After cotton farming dried up, bankrupting many farmers, fruit orchards took over many of the surviving farms for a brief time.

"Cotton went down to four cents a pound," said Evans. "Papa had some cotton, and he held over. It had gone up to twenty cents a pound and he held it over, thinking it would keep going up, and instead it dropped to four cents a pound. And he had seventy-two acres." Cotton languished in warehouses all over the county. "And so we went to fruit trees," said Evans.

"Peaches came later," said Barron. "Yeah, we used to have a peach orchard out there above the country club. We had 125 acres, and we had probably 75 of that in peaches. That's where Georgia got its name as the 'Peach State,' because there were so many peach orchards around here." By 1924, there were 300,000 peach trees in the county, shipped regularly to the New York markets. In 1928, 609 carloads of peaches were shipped from Coweta County. Apples and grapes were also popular. On Highway 27, the Evans family planted a "semicircle of apple trees." "We planted varieties you hardly ever see anymore," said Evans.

Yates apples originated in Fayette County, Georgia, in the 1840s. Described as "sweet and tart with a spicy twang," the Yates variety were small and mostly yellow, but they flourished in the heat and humidity of the Deep South.

"It's one of the best apples there is," said Evans. "They say they've improved fruit now, but it doesn't taste like the fruit Papa used to grow. They say the peaches are improved, but they're not."

Evans remembered that the apples were especially useful in bartering. When the doctor provided services to her family, he took apples as payment.

"My papa said, 'What do I owe you, Doc?' And he said, 'I tell you what I want. I want a barrel of these apples.' And it was a great big old oak barrel that Papa gave him. He hitched up his two-horse wagon and took those apples down to his house…and he thought he was well paid."

Evans said her family once maintained five hundred peach trees. "Everybody used to have peach orchards," she said. "They stayed on the tree until they dropped, and you could pick them up off the ground and they would just melt in your mouth. They were delicious."

"My daddy raised peaches, and what you would do, you would have one of these sacks with a strap around you," said Barron. "You didn't pick 'em green and you didn't pick 'em too ripe. You would get a bag full, and you would take 'em to a box and put them in there real easy, so they didn't bruise

These young women pose in the Camp Peach Orchard in Moreland in 1936. From left to right are Ruby Carolyn Camp Mills, Mary Willie Bowen Banks, Ida Lee Ellis, Elsie Mann Farmer, Catherine Poole Reding and Billie Camp Embry. The two Camp girls are from the family who ran the orchard.

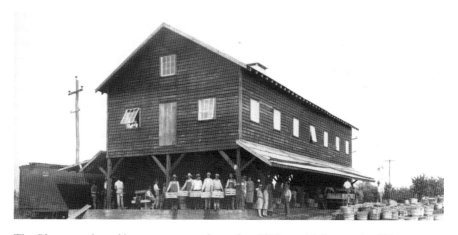

The Glover peach-packing company was located on Highway 16, just north of Newnan, next to the Atlanta and West Point Railroad. This scene, photographed in 1927, is at the peach-packing shed of Howard C. Glover.

up. And they had a tractor that would pull that flat trailer loaded with boxes out of there. They would put it on a truck." Sometimes the crop would be sold to a single canner or distributor, said Barron.

"We had some of the prettiest peaches you ever saw," he said.

"Peaches was the crop, for a while," remembered Clifford B. Glover, whose family operated a large peach farm on Highway 16, just north of Newnan. "We used to have fifteen or twenty big peach orchards. We'd have a good year, then we'd have a bad year. But they kept thinking, 'Well, next year's gonna get better.' You have to have a certain number of days of cold temperature. When it didn't get cold, the peaches did not mature."[91]

Baron said:

> *The thing about peaches is that it costs so much to look after them, and then you don't know if the cold weather is gonna kill them or not. Then, even if they don't get killed, then everybody has peaches and the price goes way down. Daddy just got tired of fooling with it. The prices weren't good enough.*
>
> *There was a fellow in the grape business who asked Daddy what he'd charge for his machinery. He said, "Meet me at my place," and the man did. My daddy said, "I want you to dig up every one one of these peach trees, and we'll burn 'em up." The man said, "We can't do that to all these pretty peach trees!" Because we did have a pretty orchard. And my daddy said, "If you won't do it, I'll go get somebody else." So that man got a bulldozer and went down the road, pushing all those trees over and piling them up. And my daddy fired 'em all up. He was through with it.*

Those trees that weren't burned or chopped down were soon taken by nature.

"All the peach trees were killed the same year, the year we had the great freeze, in 1948," said Evans. "That was the freeze that took all the telephone poles down."

"When the last peaches were all ripe, and the blooming sap was completely full on the tree, we were hit with four days of sub-zero weather," recalled Bill Miller, Evans's neighbor. "It got every tree limb, and some of the trunks in this area. They were all exposed.

"We used to enjoy peach blossoms in Moreland, all the way up the highway, it was all peaches." he said. "If you wonder why it's gone, they never returned after that. The freeze killed all the trees."

"Further south there are other sections of Georgia, down around Perry, where they still have good peach crops," said Glover. "But there are no peach

orchards in this county, anymore. That hurt. Farmers took two or three years before they just quit trying to have another peach crop."

Other crops such as corn and cantaloupes were still grown locally for years, said Evans, and truck farming and personal gardens remained popular.

"We could make fifty dollars a day selling cantaloupes on the side of the road," said Evans, which was about as much as she could earn in a day at her regular job. "We sold cantaloupes for a dollar apiece. We would be eating dinner at the house, and folks would pull up in their cars and blow their horn." The cantaloupes all came from seeds saved from about the time of her parents' marriage in 1905. "We just saved the seeds from one year to another," she said.

Evans recalled that her family planted "red rutabagas that would peel like potatoes" and "lots of peas." A man who owned a local grocery store would spend a week on their farm picking peas, "and he and his wife would shell them and sell them in their grocery store," she said. Later, Evans and her brother would plant twenty acres in peas and butter beans and add them to their truck farm sales.

"I don't know how many bushels of peas and butter beans and cantaloupes we did truck farming, but we divided it all up between us and we made good money," she said. "We were better off than most people. We didn't go hungry."

In the town of Newnan, many black families like Wilbon Clay's were subsistence farmers during the early to mid-twentieth century.

"We had a garden where we raised collard greens in the winter time this high," said Clay in an oral history interview. "We raised turnips, string beans, squash, cucumbers, okra, peppers....I loved those hot peppers. I got some strung up out there right now! I set me out four pepper plants and four tomato plants."[92]

Clay said his mother used to sell water and milk to passersby.

"Folks used to come by there and buy collard greens and eggs. We had sweet potatoes....We had to plow up sweet potatoes before the frost comes. If you didn't, they wouldn't be worth a dime. The frost would rot 'em. We'd plow 'em and let 'em lay up in the sun one or two days to cure out. We'd dig a hole two or three feet deep, fill it with straw down in there, and we'd fill it up. You'd bank it up to keep the frost from getting to them. And you'd have sweet potatoes until you ate 'em up! We had them all through the winter."

Clay said he remembers eating sweet potatoes every day when he'd come home from school.

"It was too soon for dinner. So I'd go get me a glass of buttermilk and peel a sweet potato and chunk it down in that glass and get a spoon and

stir it down around in there. It'd taste just like ice cream you'd buy at the store!"

He said the buttermilk and butter came from a calf the children were responsible for.

"My granddaddy gave it to us," he said. "Before we had the calf, we'd have to walk down to my grandmama's house with a gallon bucket, and she would fill it up with milk and put a pound of butter in there and then we'd walk home with it."

The children would help can the vegetables in the summer and make jams and jellies from the fruit, he said.

"Sometimes we'd sit up canning vegetables until twelve or one o'clock," he said.

We'd be peeling peaches. Daddy wouldn't buy just one bushel. He'd get four or five bushels, and Mama would say, "What you buy all them peaches for?" And he'd say, "Can 'em! You got all these children here!" Mama would fuss. We'd get them old washtubs and put water in 'em, and we'd pour the peaches over in there and we'd peel peaches until twelve or one at night, all of us that were big enough to handle a knife. The little ones, he'd make them wash the jars to get them ready. And we ate peaches until the jars were empty.

We raised chickens. We had a milk cow. We had hogs. But we couldn't keep the hogs in the city limits, so I had to slop them over at the hog pens about a mile from where we stayed. It was just outside the city limits.

Clay said there was "a whole row of hog pens" along a fence where "folks who lived in the city could raise their hogs" without violating city ordinances prohibiting them.

"We would raise two great big hogs every year," said Clay "I had to do the feeding. We did the slaughter and all that. My daddy would say the first ice that come, just as thin as paper, we can kill them. So we would watch for that. And I'd be so glad because I was tired of pushing that slop."

All the leftovers from the family table went to the hogs, Clay said.

Fattening came during the summer peach season. We had two or three packing sheds. We'd cull the peaches out, and all the bruised ones we'd dump in a ditch. We would get an old ox cart and load it up, then dump it all in the hog pens to fatten them up. You know, people used to raise them to see who had the biggest and fattest hogs, and some would come out looking

like they weighed four or five hundred pounds, I'm telling you. We kept the meat until the next year, so we didn't have to buy any.... We would cure it, pack it in salt and take it out after thirty or forty days and wash it, clean it, hang it up and then put that hickory smoke out there under there, and Daddy would say, "Smoke that meat, boy!" You could smell it through the town, one of them hams. We didn't have to buy no boiling meat, no lard. And we did it all ourselves.

"Back then you didn't have any way to keep anything—no refrigeration," recalled Jack Hunter of Turin, Georgia, in an oral history.

"When we killed hogs we'd make sausage, and we'd go ahead and cook the sausage. And you put the sausage in jars and then pour the grease on top of it. And then when you got ready for sausage, you'd just open the jar and heat them up again, throw them in a pan and heat them up."[93]

Hunter remembered that his family had "a closet in the kitchen, full of jars," and "jars in the smokehouse," too. "We used to stuff a lot of the sausage in the casings and hang them up to let them dry, and you could keep them a little longer by putting smoke on them. The casings came from the

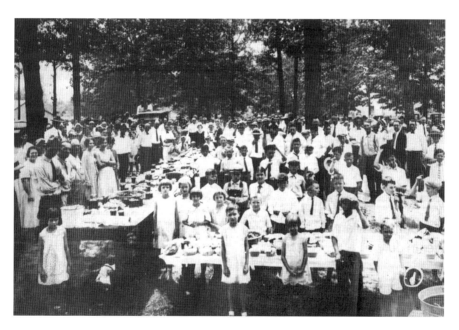

This photo was made in Turin, Georgia, probably on a hot summer afternoon in the 1920s. Neither the exact location nor the people could be identified, but it is thought to be a barbecue by Looney Arnold with attendees including Emily Shell (Parrott), Sam Shell, John Blake Shell, Josephine Summers and Leroy Johnson.

Canning was often taught at "home demonstration day" events. Here Coweta County 4-H Club member Betty Bowers shows her canning project to home demonstration agent Margaret Fargason in 1939.

intestines of the hog. You turn them and scrape them, and then you had to stuff them on this grinder and put the meat in the casing."

When he recorded his oral history interview in the late 1990s, Hunter lamented that it was becoming more and more difficult to find quality hogs.

"We kill hogs all the time," said Hunter. "About the last two years, it's got where you can't hardly find them. I'd buy hogs every year, and you know, kill them. And I like to kill my sausage like I like them. And I like to kill my ham like I like them." He elaborated:

> *What I do with the ham, I put them down in salt and leave them five weeks, and then take them up and wash them real good and put them out in the sun and let them dry. And then I take red pepper, black pepper and syrup and water to thin it down. And I put that all over, and it makes it look bad, and then I get some brown paper and wrap them in that and then I always get them some white sacks and hang it up in the smokehouse. And as long as you let it stay there, that stuff I made with the syrup and flour will seal them, and as long as you let them stay there, the better they get. But the trouble is letting them stay there, you want to cut them. . . . They was good. And with all that*

black pepper and red pepper I put…we never had any trouble with any flies.
Yeah, that was some good ham, some fine ham right there.

Hunter said that before refrigeration "you couldn't buy anything in the store except salt pork." Later came chickens, "and when it started you could cut up your chicken to frying size, and whether it weighed a pound or two pounds, you could get a dollar apiece for every chicken you carried to town."

A typical winter farm activity for many years was the "hog killing," like this one at the Stapler homeplace on Roscoe Road.

Kathleen and Jack Hunter operated a farm in Turin for many years. They recalled making their own sausage and sharing cuts of fresh beef with neighbors on a rotating basis, prior to refrigeration.

The stores would "put it in the coop behind the store," and when customers would call and ask to buy a chicken, "they'd tie the legs together and… they'd have a delivery boy with this little old basket on his bicycle.…But that was all you could buy, salt meat and a live chicken."

Killing and eating beef was a social enterprise prior to refrigeration according to Hunter.

"How we done it around here, there would be about ten or twelve families and we'd have a five hundred pounds or three hundred pounds or whatever size, and we'd cut it up and then how many that was in the group would get their share of the cow," Hunter said. "Because you couldn't keep it. Beef you couldn't keep in salt. You'd have to cook it that day. Maybe you'd have beef for three days."

The following week, someone else in the group would kill a cow, he said.

"You couldn't go to the store and buy any beef," he said. "But we'd have beef for several weeks in the fall of the year. Each person would kill a cow and then cut it up into cuts and everybody would get their share."

Shopping was social in those days, too.

"Most of the time we'd go more I guess to Newnan or Senoia, really. You go up there to Turin on a Saturday, and you couldn't get into Turin for the wagons and buggies and things, there'd be so many people up there. And, you know, they had to come a far piece, 'cause there weren't that many people in the country then."

Shopping in town offered "a place to meet up and talk, too." he said. "You'd hear and tell all the news. That was the only way you got the news from one to another back then."

"YOU CAN LOOK AT MY HANDS"

The earliest industry involved pulling what was needed right out of the ground or—in the case of a family of artisans like the Gordys—from the muck of the swamp.

"Go down to Senoia, like you're going to Manchester. Back off White Oak Creek, there's a little place called Alvaton, and that's where we got all our clay and everything," said Herbert Gordy. "We had to go where the clay was. There was two or three kinds of clay, and there was a difference in it. You could take a piece of white clay and after you'd fire it, it was still white. But you take a piece of swamp clay and bust it open, and it was yellow."[94]

The Gordys "hauled the clay right out of the swamp," he said. "We'd transport the clay and bring it down from there—we had us a thing, a sixteen-foot-square pile of clay. We got our clay probably a mile from the clay kilns."

The Gordy family was famous throughout the area for making clay pots and jugs, all of them stamped with the Gordy signature: "W.T.B. Gordy, Alvaton, GA." William Thomas Belah Gordy learned his trade from his uncles Henry and Jasper Bishop in "Jug Town," Georgia, near Thomaston. Herbert, who later lived in Newnan and became known for his woodwork, was one of Gordy's four sons.

"We would hook up a horse and wagon and go around to all these stores and churches in LaGrange, West Point....My brother was the salesman," he said. "Most of it back then was stuff you would use like jugs, churns.

Everybody had a churn. We made pitchers and jugs. You'd put whiskey in a jug, syrup in a jug."

Included in the wagonload might also be "decorative stuff" made by his mother. "She would take those things when they were still wet and make an ear of corn or something that looked like it, or a rose. It was real pretty," said Gordy.

In his early *History of Coweta County*, Anderson recalled that local industry had modest beginnings. "We could not get any grinding done except at the river mills," he said, "and they were so crowded it was about a week's trip to go to mill and get grist of meal." The first mill in Newnan—where there were no rivers available—was operated by "a hand with two cranks," said Anderson. "It was kept running day and night, and they afterwards geared it up for horse-power, and ran it for some time.":

> *We had no steam-power then in the country; everything was hand work. We made our wagons, carts, and all our plows, axes, farming tools at home. We had our smoke-houses at home, and corn-cribs in our horse lots, and if a neighbor had to buy corn or meat, he did not go to Tennessee or Ohio for it. He went to his neighbor and got his supplies.* [95]

"In the days of slavery, each plantation was a place of diversified industries," said one inventory of early manufacturing:

> *The blacksmith shop provided many of the implements, tools, utensils, furnishings, and building accessories of the time; hand wrought andirons, hinges, shovels, tongs, and pokers, are a few that instantly occur to one.…The plantation carpenters were often skilled artists in cabinet-making…though their main business was to manufacture handles for the tools made by the blacksmith—axes, hammers, hoes, rakes—they were often called on to make an attachment of implement in connection with the women's special work of weaving; I recall a home-invented, and home-made, reel for filling the bobbins for the loom. No patents were taken out, but the number of inventions was a large one. Much has been written of the South's backwardness in factory building, but why should she have built factories when her people so capably made most of the things they needed?* [96]

In 1851, the Atlanta and LaGrange Railroad came to Newnan, setting the table for future growth. "The line was completed and opened for passenger

Above: A clay jug inscribed with "WTB Gordy, Alvaton, GA," from the private collection of Grantville resident Darwin Palmer.

Left: Craftsman Herbert Gordy at work at his shop in Newnan.

trains to the Palmetto depot on March 17, 1851; to Arnold's (now McCollum) on June 3; to Powell's (now Madras) on July 13; and to Newnan on September 9, 1851," according to the *Chronicles*.[97] R.D. Cole & Co. was established just across the street from the Newnan Depot, eventually operating a foundry and machine shop as well as saw and gristmills, becoming one of the largest employers in Newnan and playing a pivotal role in building the town. The first cotton warehouse was opened soon afterward. "A little settlement, called by the homely name of Calico Corner, because of the coming of a railroad became Grantville, and took a start to grow into a good business town."[98] Additional rail lines were constructed that eventually led to the development of towns like Senoia and Sharpsburg. While white children were "thrill[ed] with excitement at the coming of the trains," young black slaves mingled with the free blacks who were building the new rail lines and dared to dream of "running away" on the trains and "going to the free states." Some ran and hid in the woods, burrowing holes into the banks along White Oak Creek and biding their time until they could find some passage north.[99]

The sawmills popping up along the new rail lines would pile their shavings in towering "mountains of sawdust," remembered Frank Barron.

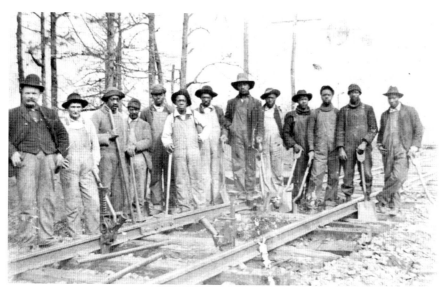

Overwhelmingly, the labor of constructing the county's infrastructure, such as railroads and roads, has fallen on African Americans, either as prisoners or as cheap labor. This photo taken in Madras, Georgia, around 1920 shows a "railroad section gang" led by Noah Monroe "Doc" Morris Sr. *(far left)*.

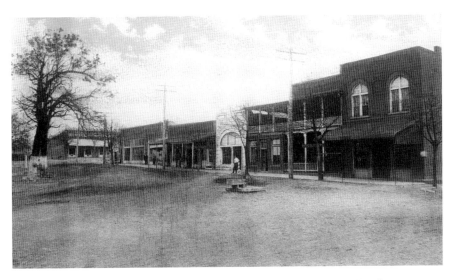

A postcard showing Railroad Street in downtown Grantville, formerly Calico Corner.

"I remember a building supply place, Askew, used to be Royal, they had a big old sawmill on First Avenue that run off steam. You could hear them sawing that lumber, with the blades going through those logs. I would go to sleep hearing them," said Barron.

"It was a big outfit," he recalled. "They sawed local lumber, mainly pine. They had a huge pile of sawdust shavings they kept moving around until it made just a mountain of sawdust over there that we would slide down and make tunnels in and slide all around in it. We had a time."

Cotton mills and rope and yarn manufacturers were organized in Newnan and surrounding areas following the Civil War. The beginnings of the village of Sargent, growing up around what later became known as Arnall Mills, were seeded in 1867, with an investment equaling, in today's terms, nearly $2 million:

> *Captain H.J. Sargent, Colonel J.B. Willcoxon, and George Sargent, of "Sargent cotton cards fame," under the name of Willcoxon Manufacturing Company built a factory of stone and brick, four stories high 50 x 80 feet, with fire-proof picker room separate, on Wahoo creek, at a cost of $60,000. An overshot wheel thirty-three feet in diameter developing fifty horse-power furnished the power for the operation of twenty-one hundred and fifty-two spindles for spinning, and three hundred fifty-two*

for twisting. With fifty operatives turning our two hundred bunches of cotton yarns a day...[100]

"We moved to Sargent when I was two years old," recalled Ed Camp in a 1999 oral history interview. "I was raised in the mill village. At that time, it was called the Arnall Mill. That was in 1931. My dad and mother both worked in the mill. My great-granddaddy had a farm in the area there, on Cedar Grove Road." But when his grandfather decided to leave the farm, many of his family members followed.[101]

"My dad was never into gardening," said Camp. "My grandmother's brother, he was the first one in in the family, I reckon, to come to Sargent. He was here a year or so before us and probably accounts for us being here. My grandmother worked in the mill for a while. To me she was an old woman, but I know now she wasn't.

"My mother worked in the sewing room, where they made blankets. We called them cotton sheet blankets, but they were similar to what we call flannel sheets now, but they were a little heavier."

Across the creek, at the Arnco village, the newer factory there made a "blend that was part wool," that was a "heavier weight," he said and "a lot nicer blanket."

"When I was a little boy living in Sargent, I didn't even have an inkling of Arnco," said Camp. "There was no thought in my mind of Arnco until we were in school. We had a place for recreation in the Wahoo Creek, in the bend there between Sargent and Arnco, that's where the boys went skinny dipping. Mr. Henry Bryant lived in the house there, and we'd be down there skinny dipping and he'd raise hell. And rightfully so. But at that time, the boys from Sargent and the boys from Arnco would get on different sides of the creek and throw rocks at one another."

Arnall Mills had an operation that could take items from the farm to the finished manufactured product, Camp said.

"The plant at Sargent only made cotton yarn, at first," he said. "Later on, they made blankets. But they did everything to get to that stage. Arnall Mills had a farm, where they raised cotton. That wasn't all the cotton they used, but it provided some of it. And they had a gin at Sargent. And they would gin their own cotton, and also the cotton for other farms around in the area. And of course they brought cotton from the outside."

The factory included a dye house, a weave room, a spinning room, a napper building and a warehouse. "Mother was in the sewing room," said Camp. "After they cut the material, they just hemmed or stitched the edges.

Some of the blankets, they called them 'pairs.' It was like a double blanket, or double the length. It was great in the winter time because your feet wouldn't get out at the bottom. You'd just fold it over."

The whole village supported the mission of the mill and the people who worked there. There was a company-operated store, a doctor, a social worker, a school, ball fields with local teams and homes with electricity and running water—amenities often absent from rural farms.

"We lived in the mill village, in a house they had just completed," said Camp. "They told me they had just built the house in one of the old cotton fields, in what they called the 'New Town' part of Sargent."

"The first houses in Sargent were built on the street fronting the [original] Wilcoxon Mill, near the creek and on Macedonia Road," local historians wrote in the Sargent Historic District application. "The company added significantly to its housing stock when they built the 'New Town' residential area in the late 1920s."

"There were three streets over there, two off the main street and one between those two," said Camp. "I don't know how many houses were in there. We lived in a shotgun house that had three rooms. We lived there until right before the war. Then we moved into another house, a four-room house; it was still a mill house." He went on:

> Still up until this time the mill company owned the houses. It was a better community then. The mill required people to—they didn't allow any rowdy people. It was a better community. It was a great place to live. I cherish that fact. The fact that I was raised in a mill village, a lot of people think that has negative connotations, but to me it was the same as being raised anywhere else, and we had mostly good people. Overall, people looked out for one another, and they looked out for the children of the parents when they were working. We had a school. When I started there, it went all the way to the 11th grade—it was a high school....We always knew we had to be careful, because your neighbor would tell your parents on you. And your parents didn't react like someone does today. We didn't have to worry about anybody stealing anything. We didn't lock the door. (I didn't lock my door until I moved out of the mill village. The first week after I moved, somebody stole the bicycle off the carport!) All of us were poor back then, but we didn't know it, because everybody was poor.[102]

Black residents were also considered a part of that mill community—even though they were largely segregated—he said.

"The mill had a farm, and the workers on the farm, all that worked on those farms were the blacks," said Camp. "They were the ones picking cotton and plowing."

Black workers were also allowed to work in the mill's "opening room," which Camp described as "a bad job, a low job, opening bales of cotton, loading and unloading it, places where there was a lot of dust." Black workers could also be assigned as laborers to the shipping department or the dye house.

James Gay recalls working at the dye house at the Newnan Cotton Mill, "but it's not something I'm proud of," he said.

"That was hard work. But would you believe that when I went to work there, we weren't even hourly salary? We got paid on the weekend, seven dollars," said Gay:

> You worked early in the morning 'til late at night…no extra pay when you worked extra. We were doing cotton, rayon and wool. I went to work at the dye house. We didn't have synthetic then. We had a turbine. And there was a big vat, as long as this room here, yea wide, yea deep. It had holes to pump the water into and a heater to heat the water. You'd heat it as hot as you could get it and then put the dye in it….We'd have sticks about this long to turn the yarn. We'd turn it and turn it. Rayon especially was hard. It would be heavy….That water would get so hot, you couldn't let any of it hit you anywhere. It would burn you. So many people had burns on their hands and on their faces. No protective gear. We didn't even know what protective gear was, in those days, 1937 or 1938. And this is what I was doing for work in the summertime, after school. As a boy.[103]

"We knew they were black, and at that time, we knew blacks and whites didn't mix," said Camp. "There was a big cotton field, and right over here is the blacks….We played with the boys, we grew up with them….We weren't old enough for the prejudice to set into us. We played with them and fought with them and everything else, because they were just across that field. So we knew them."

Even though the white villagers considered themselves poor, many still had black servants—including the Camps.

"Yes, we had a maid. She came when my mother and daddy both worked, when I was younger," Camp said. "When I got older, we didn't have a maid, but then when my brother came along, we had another maid.

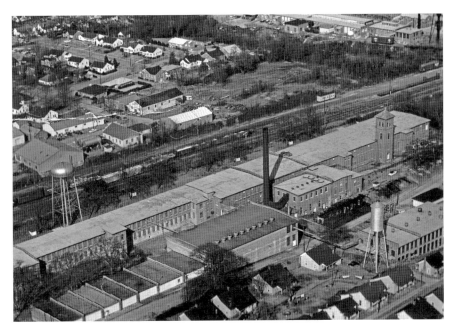

Newnan Cotton Mill was a major producer of novelty yarn for much of the twentieth century and a top local employer. Note the "saltbox"-type houses—a common architectural style in New England, with its sloping roof and two-story front, but much less common in the South.

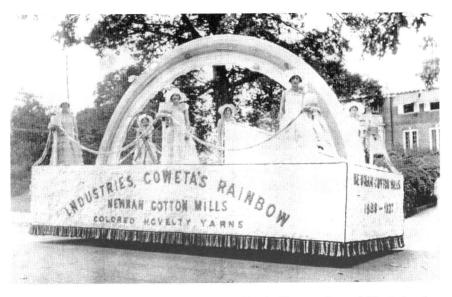

"Industries, Coweta's Rainbow," a float sponsored by the Newnan Cotton Mills, "colored novelty yarns." The front of the float, an entry in Newnan's Centennial parade, reads "1888–1927." On the float are (*from left to right*) Myrl Kelley, Lorene Lively, Effie Hicks, Winnie Campbell and Agnes Cash.

James and Katie Gay. Mr. Gay remembered working at Newnan Cotton Mill, which he described as dangerous. This photo was taken at their home on Pinson Street.

Frank M. "Bo" Barron and his nephew, Harold Barron, photographed in 1999 at 21 Buchanan Street. Frank Barron was born in 1906 and was ninety-two years old at the time of his interview. He was one of twelve Barron children.

We didn't call them 'maid,' though. We called them cooks. That's the term everybody used."

> But she did the housework and prepared the meals. When everybody came home at 3:00, she had the meals, what we called supper. What we called "dinner" is called "lunch" now. But we'd eat corn bread and black-eyed peas and potatoes. And we'd take our cook back home. Those people were basically like one of the family. There was a bond between them and the family, in the case of our family anyhow....She was just one of us. We loved her just like anybody else.
>
> Blacks and whites did not work side by side at the mill for a long time. They basically separated them. And then, finally, they started using some, inside the plant and running the machines.
>
> The black community is still there. In some places, the blacks have houses in the white areas. In my days, no blacks lived in the white community. You know, it's been a hard road for the blacks. I realize they were mistreated. I feel for them. It's hard when you're brought up and you have prejudices, even though in your heart you want to be different. It still jumps up at times and influences your thinking. When I became a Christian I had to put aside my prejudices, even though it's something you grow up with. But you have to suppress it, because it's not right. It's just not right.
>
> We really do not have integration now, and I don't know that between the races there will ever completely be just a feeling of warmth....We've got a long way to go. Even though the black community has made a lot of gains, it's still there. They are as good a people and have as good a heart as any I've ever dealt with.

Clifford Glover, a supervisor, remembered he "had to keep the humidity level high" at the Newnan Cotton Mill to keep the looms running at peak efficiency. "They had about thirty-five women in a room they called the mending room, where they would mend the fabric that had errors in it, you know," Glover said. "I had to be in there with all those women, and it was the hottest place in the world. They didn't have air conditioning, in those days. And you couldn't open the windows. It was stuffy."

He later moved up to become the company's "efficiency expert."

"Time studies was the thing to do," said Glover.

"Every job in the mill had their setup with what the workloads were and how many machines one person could handle," said Glover. "More spindles, more frames, whatever it was."

Left: Clifford Banks Glover said that safety conditions were horrible at the Newnan Cotton Mill. He worked as a supervisor at the mill for many years.

Below: Black nannies were the norm for most local white children in the 1800s and the first part of the twentieth century. Pictured here are Catherine and Margaret Passolt with their nanny, whose name is unknown, at their home on 148 Greenville Street in Newnan.

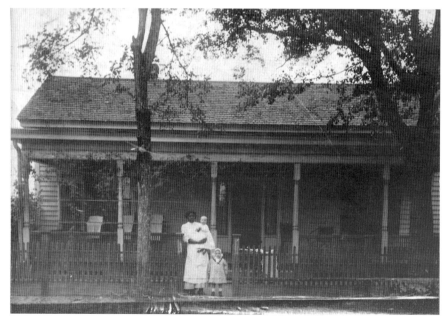

It was easy to see that "some people were slower than others," Glover said. "But you had that stopwatch, and you had to prove it."

Once it could be proven that a worker "was not doing the average of what the others were doing," that worker would be assigned to a different task, he said.

He eventually moved over to the standards and safety department.

"The safety record was terrible out there," said Glover. "A lot of people would get cut. Some of those machines would be running so fast that you'd cut yourself by just barely touching it with your finger. We had terrible accidents."[104]

Frank Barron recalled working sixty hours a week before the National Recovery Administration (NRA) implemented labor reforms during the Franklin D. Roosevelt administration.

"That was at ten cents an hour," Barron said. "That's working on Saturdays until eleven o'clock."[105]

Working conditions got so bad that a General Textile Strike was called by unions in 1934, shutting down factories all over the Southeast. The *Newnan Herald* outlined the issues in its September 28, 1934 edition:

PRESENT STATUS

The fundamental issues involved in the strike boil down to…

1. Recognition of the Union and methods of collective bargaining.
2. Machinery for handling complaints of violations…and other provisions of the Code.
3. Hours and wages.
4. Stretchout.

The "stretchout" was a term workers used for a system devised by mill owners to get more production using fewer people, as a way to skirt around or compensate for the new labor laws put in place by the Roosevelt administration. A 1934 memo to Roosevelt described the stretchout:

Men and women are being killed inch by inch with this terrible system. During the last few years, men have been carried away from their work dead or unconscious. I ask you to read of the cruelty of Pharaoh to the Israelites to get a comparison. Although the Israelites worked in fresh air while the mill people were shut in and have to breathe the same air over and over

again. The time is near at hand where there will be no old people in the mill villages because of the stretch-out system.[106]

Etta Mae Zimmerman was fourteen when she went to work at the East Newnan Textile Mill, "guiding cotton fibers in the noisy looms for $1.88 a day," the *Atlanta Journal-Constitution* reported. "She clearly remembers when she first learned about labor unions. 'An overseer said Leona, my sister, was trying to organize a strike. He told her she'd better mind…. But Leona didn't even know what a strike was. She was just crying and crying.'"

At the time a bitter governor's race was raging, with incumbent "boss" Eugene Talmadge being challenged by Claude C. Pittman, running as a workers' advocate and staunch supporter of the NRA. "Is Governor Talmadge Labor's friend?" Pittman's supporters asked in an August 31, 1934 edition of the *Herald*. "In opposing the use of the CWA wage scale, set up by the government at the urgent request of union labor, Governor Talmadge openly stated that no laborer in Georgia was worth more than a dollar a day."

A campaign song in the *Herald* called "The House of Talmadge" also poked fun at Talmadge's anti–New Deal, anti-labor tendencies:

> *He's fought the President each step of the way,*
> *The recovery act and the C.W.A.*
> *He said the boys were loafers and bums,*
> *Because they asked for a few little crumbs.*
> *Some poor mother was to feel sad,*
> *And Gene said: "The president was mad!"*
> *One dollar a day for the working man,*
> *That's how Gene likes the recovery plan.*

Talmadge spoke in Newnan in the midst of the strike, painting himself as a friend of labor who would never resort to using the military to end a strike. "Citizens, probably mill employees near Newnan, held placards with 'We want protection, or give us another governor' [and] stood before the governor all during the speech," reported the *Newnan Herald*. "I am a laborer myself," he told one campaign crowd. "You can look at my hands, and the color of my skin, all tell it."

The strike began on Labor Day, September 3, 1934. "The general strike of textile workers, which has been brewing for several weeks in sections of

the South and East, culminated over Labor Day, with the closing of a large percentage of the textile mills," the September 7 *Newnan Herald* reported. "By Tuesday evening all of the cotton mills of Newnan had closed."

Meanwhile, so-called Flying Squadrons were being dispatched by union leaders throughout the Southeast to support and encourage strikers. Locals who opposed the strike seized upon these squadrons as "outside agitators." "Monday morning about 5 o'clock, approximately forty cars and three truck loads of strikers, reported from the mills at LaGrange, came to the Arnall Mills at Sargent, and to Arnco Mills, and picketed them," the *Herald* reported. "Tuesday morning McIntosh and Newnan Cotton Mills were closed."

"They had a bunch of what I would call hoodlums come in," said Barron. "It wasn't an organized bunch....You couldn't go to work, you couldn't get in, you couldn't do anything. There wasn't nothing you could do. They closed it all down."

Strikers recalled singing hymns like "I Shall Not Be Moved" as they encouraged workers to come out of the building and shut down the machines. "People would filter out of the mill, come down the steps, and as they did everybody would shout, 'Hooray! Come on!'" recalled Joe Jacobs in the film *The Uprising of '34.*

The *Newnan Herald* called the situation "unprecedented in the annals of Coweta's history."

"The textile industry, employing approximately 5,000 workers, has been forced, by outside interference, to close its doors to its workers, the majority of whom have signified by signed petition their willingness and anxiety to resume their work," the *Herald* reported.

Local mill owners and managers purchased a large ad to outline the situation to the public:

To the Citizens of Coweta County

Last week a call for a general strike in the Textile Industry was issued by the leaders of the United Textile Workers of America, the strike to become effective at 11:30 p.m. Saturday, Sept. 1st. The local union at the Grantville Mills notified the management that they would respond to the call, and the management announced that the mill would be closed. On Monday, September 3rd, all others of the undersigned mills opened as usual with a full complement of operatives except McIntosh Mills, which observed Labor Day holiday. Before opening time, several hundred persons brought in trucks

from LaGrange and other points outside the county presented themselves at the plant of Arnall Mills at Sargent, each armed with a stick, and tried to prevent operatives from going to their jobs. With the assistance of the Sheriff and his Deputies, a way was forced through the mob, and the workers escorted into the mill. The mob stayed at the mill all morning, continuing their threats and menaces, until the management, unable to give adequate protection to the operatives, announced the closing of the mill. As the mob threatened to repeat their performance at the Arnco Mill, this mill also was closed. On Tuesday morning, another mob presented itself at the Moreland Knitting Mill, McIntosh Mill, National Dixie Mill, Newnan Hosiery Mill, and Newnan Cotton Mills, and created a similar situation, forcing the mills to close....Twenty-one hundred and twenty textile employees at work on their jobs in seven mills in this City and County have been forced out of their jobs the last two days....Our industries, which are depended upon for a large part of our tax burden, will be severely handicapped and crippled. The $25,000 weekly payroll of these people will be lost to our merchants. But most serious of all, perhaps, is the complete overthrow of constituted authority, upon which all of us, high or low, rich or poor, must depend for the protection and enforcement of any rights we have.

A.W. Arnall, President, Arnco and Arnall Mills
R.S. Mann, Secretary, Newnan Hosiery Mill

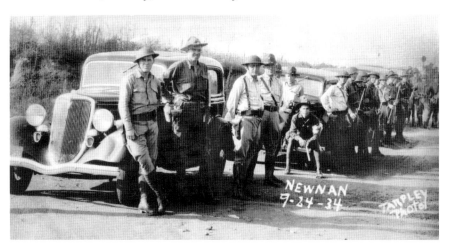

The Spalding Grays, Headquarters Company Thirtieth Division, is shown here during the General Textile Strike of 1934. This photo was taken on September 24, at the end of the strike. Five companies of the Georgia National Guard were called to Newnan by Governor Eugene Talmadge to break the strike.

George Carson, Manager, National Dixie Mill
W.N. Banks, President, McIntosh Mill and
Moreland Knitting Mill
R.H. Freeman, President, Newnan Cotton Mills.[107]

With the governor's election outcome uncertain, tensions rose quickly. At Echota Cotton Mill in Calhoun, Georgia, owners transformed the mill into an armed fortress. The mill president placed barricades around the plant, had "tough country men" deputized and stationed at intervals with 12-gauge pump shotguns and placed a .30-caliber Browning machine gun on the roof.

Camp said that similar preparations were being made in Sargent.

"I was just a small boy when that happened, just five or six years old, but I have a memory of it," said Camp. "One thing I will always remember is that they had a machine gun set up there on the lawn,

Ed Camp grew up in the mill village of Sargent and recalled its rivalry with the adjacent village of Arnco. He also vividly remembered the guns set up around the mill during the Strike of 1934.

just like they were gonna mow people down. I remember this from seeing it, not hearing about it. A kid that old, a first impression can be made."

A government relief office opened a branch in the Cole building on the Court Square "for the benefit of those who have been thrown out of work by the textile strike in the Coweta textile mills," the *Herald* reported on September 14. "The new office will take care of the employees of Newnan Cotton Mills, Arnco Mills, Arnall's Mill at Sargent, etc."

In the same edition, it was announced that Coweta County and the entire State of Georgia had "gone for the governor" and reelected Eugene Talmadge. "All Power to Our Governor!" read the local news headline. "It was one of the most heated campaigns Georgia has ever experienced and the supporters of each candidate must surely be glad that the election is over."

Within the week, Talmadge would renege on his promises to the workers, declare martial law and send the National Guard into Newnan, rounding up and arresting 112 men and 16 women strikers.

"I carried a load of them up there to Fort McPherson myself," recalled Barron. "We had an old truck with sirens on it….I must have had fifteen or twenty on the truck I had."

"I didn't think I had done anything wrong," said Zimmerman, one of those arrested and sent to prison camp. "All we were trying to do was get people to join the union. The boys that came and got us felt bad about it. They apologized and said, 'I think this is terrible.' But I don't blame them. I blame the government."

The *Herald* was ebullient in its praise of the arrests. "Georgia Is Proud of Her National Guard," the headline rang out: "The personnel comprising the National Guard companies that have been placed in this area are to be congratulated on the splendid manner in which they carried out their assignment here in Newnan.…The Guardsmen have carried out their duties in a manner worthy of commendation.…General Camp has under his command a powerful military organization that has spread itself over our state and brought peace and protection to our working people." The piece continued:

> *National Guards Protect Loyal Textile Workers as Coweta's Mills Open*
> *Five Companies of National Guardsmen are Stationed at Newnan Under Command of Major W.L. Harwell*
> *Troops Pitch Camp at Old Fair Grounds*
> *Telephone, Water and Lights have been installed in the National Guard Camp*
>
> *Adjutant-General Lindley Camp brought a "flying squadron" consisting of National Guards to Newnan Monday to meet the "flying squadron" established around the textile mills here. Cars of strikers began coming into Newnan several hours before daybreak. By 8 o'clock the mills were well picketed, and crowds had begun to gather around the mills. A few hours later a car of officers came and stopped in front of the Newnan Cotton Mill. A few seconds later several truckloads of National Guardsmen arrived, surrounding the strikers completely. They came quietly with the soldiers, were put into trucks, and carried to an internment camp near Fort McPherson.*[108]

"Some of my relatives had to leave Sargent because they sided with the people who were striking," said Camp. "I didn't see it, but I remember them taking them away, and my understanding was they put the people in wire stockades.…To me, it was a scary thing, seeing something like that."

The strikers were treated "just like they were criminals," said Camp.

"But they were really just trying to organize," he said. "They didn't want them to organize.…They wanted better working conditions and pay. And nothing came of it."

The governor's militarized shutdown of the strike broke the back of the labor movement more or less permanently in Coweta County and throughout the state of Georgia. The flame was extinguished, the leaders blacklisted and grievances of the workers largely ignored. For many years, the strike was not spoken of.

Without outright acknowledging its role in the matter through its laughably one-sided coverage, the local newspaper did go so far as to point out afterward that the problems brought up by the workers still persisted. "The general strike that pervaded the ranks of the textile industry and crippled business generally during the past few weeks has been cleared over and all seems well at the present time," reported the *Newnan Herald* on September 28. "But no settlement was reached. Things are just where they were when the strike started. The grievances have not been patched. The wound is not healed."

Camp said he remembered when he went to work for the mill years later that they found a cache of guns that had been stockpiled by management during the strike.

"They found the shotguns. They had bought some sawed-off shotguns. I don't know what they were gonna do with them, but they stowed them at the warehouse, and a lot of years later they found them. I have one of the guns right now. It's a sawed off pump shotgun that they bought during this period, in connection with the strike."

Now the mills are all gone, transformed into apartment buildings or crumbling into dust. Local manufacturing jobs have been replaced, for the most part, by low-paying retail jobs. Barron said he left the mills himself a decade after the strike, in 1948.

"I felt like I wasn't getting the pay I should for the work I was doing," said Barron. "They had 1,100 employees during the war at the two mills. People in the mill were getting worked overtime....I was making $215 a month and I asked for a $35 a month raise. They stuttered over it. So I left."

"LEADING THE WAY IN THE WORLD"

The fear of integration is what ultimately propelled a second Newnan attorney into the governor's office.

Eugene Talmadge was serving his third term as Georgia governor when he launched a series of public attacks against a University of Georgia professor, Walter Cocking, dean of the College of Education and an Iowa native—an outsider brought in specifically to improve Georgia's education standards. Talmadge alleged that Cocking was a communist and using his position to integrate an Athens demonstration school.[109] Talmadge said that he would remove anyone in the university system advocating integration or racial equality. He targeted Cocking's association with the Rosenwald Schools, such as those built in Turin and Grantville, denigrating them as "Jew money for niggers."[110]

"I made fifty a month teaching in the 1940s," remembered Ollie Evans. "Eugene Talmadge said at the time, 'If you don't like what the state is paying you, you can get out and pick blackberries for a living.' That made Papa so mad. He had three daughters teaching school. He just hated Eugene Talmadge. You know, Talmadge was known for wearing those big ol' glasses. Papa had some like that, and someone told him, 'You know, you look just like Eugene Talmadge.' Well, soon after that, Papa's glasses went missing. He later admitted he just threw them away."[111]

But Talmadge was very popular with his rural constituency. "You see, it was almost impossible to beat Talmadge," said Ellis Arnall, who served under Talmadge as the state attorney general. And in the case of what became

known as the "Cocking Affair," Talmadge got what he wanted—Cocking was fired. But it came at great political cost. The University System of Georgia lost its accreditation due to Talmadge's political interference.

"I remember I was at University of Georgia for two years, and Eugene Talmadge had interfered with the Board of Regents, with one of their appointments," remembered Virginia Mottola of Roscoe. "The University of Georgia was taken off the list of accredited colleges. The school lost its accreditation. So I had to transfer to the University of North Carolina. When I did, I lost so much credit. I lost twenty-five hours!"[112]

It was a huge, sensational scandal. Arnall saw this as an opportunity.

"I called the Associated Press and the news media and announced that…Talmadge had no right to remove members of the Board of Regents simply because they would not do his bidding," said Arnall. "So overnight I was projected as the champion for the Regents, the University System of Georgia and academic freedom…I had the university issue to pull Talmadge down."[113] Arnall used the issue to beat Talmadge and became Newnan's second governor in September 1942. Like Atkinson before him, he was young and progressive.

Newnan attorney Ellis Arnall pledged to "crusade for decency" against longtime incumbent governor Eugene Talmadge in 1941.

Arnall was a product of the local public school system, where he got his first indication that he would one day become governor:

> *In the first grade grammar school in Newnan, my teacher was Miss Maggie Brown. On Halloween she had a fortune-telling contest—put slips of paper into a wishing bag, with the names of businesses, professions or trades that we children would follow, and I drew one that said, "Governor you will be." Having no idea what a governor was, I took it home to mother, and she explained to me what a governor was with some degree of pardonable pride. So I knew from that day I would be governor of Georgia.*[114]

The first school in Coweta County was established in a rough log cabin in the middle of the Newnan court square, the center of everything, almost as soon as the town was founded in 1828. "Dr. J. Palmore taught the first school in Newnan, in the Courthouse in the square, this year," Anderson noted. It wasn't until 1884 that the first true public schools were established. Meanwhile, the private academies—or "seminaries"—such as the Male Academy were reserved for white boys whose parents could afford the privilege and could spare them from the daily workings of the farm. Newnan became known for the education of young white women, as well, thanks to the vision of Moses P. Kellogg, who came to town "almost penniless, without friends or acquaintances," Anderson wrote. But with his "good resolution and strong constitution," he founded a women's school, College Temple, in 1853, on what became known as College Street, on the north side of town:

> *He has averaged one hundred pupils each year, with an average of ten graduates each year. Many have been taught without fee or reward, except to feel and know that none have been turned off for their poverty. College Temple has added more to Newnan than any other institution in this place, and is the result of an individual, by his own exertions, and from the patronage given him from his merits as a teacher.*[115]

"The limitations and longings of the college bred women of this period" were noted in the College Temple newsletter, the *Fly Leaf*:

> *WOMAN—AN APPEAL*
>
> *I doubt not the question, "Where can I find honorable and paying labor?" has often perplexed educated woman as she leaves the walls of the academy*

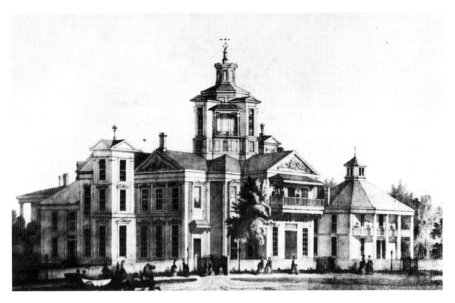

College Temple, built in 1853, was located between College and Kellogg Streets and Temple Avenue, one of the first colleges to offer a master of arts degree for women.

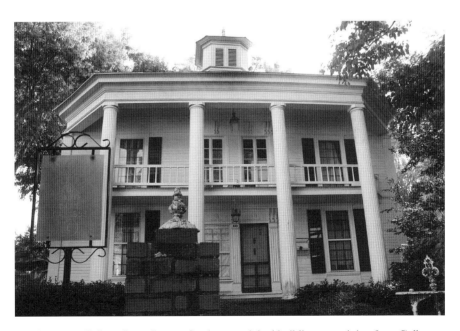

This home on College Street is one of only two original buildings remaining from College Temple. This building served as the science laboratory. The rear of the building is identical to the front and served as the entrance from the college green.

or college. She looks around and finds to her amazement, that the sterner sex have closed against her the door to nearly every avenue of fame. "I must live," she says, "at the same time I desire to gratify a laudable ambition—and what must I do? I cannot seek and obtain offices, for the laws of man have prohibited me. I cannot mount the hustings and be corrupted by political excitement, for I would lose the respect of the good and brave! I cannot become an advocate or attorney, astonish the Judge on the bench, draw tears from listening and attentive Juries, by the magic of eloquence; contend with the learned and unlearned, because every dictate of prudence and propriety is against it! I cannot compete successfully with man as a physician, because I could not perform many of the duties required at my hands! What then must I do?" After this survey, she exclaims, "I must stitch, stitch, stitch, confined to the four walls of my room. All my bright dreams of glory and success have proved but as the will-of-the-wisp which has led me into desolate regions and left me forsaken and forlorn. My lot is hard—a weary and restless existence is mine. I may moisten with tears my pillow by night, and dream of glory by day, but I cannot change my destiny. I am caged. My intellect is fettered."[116]

It wasn't until after the Civil War that the first school for black students in Newnan was founded, according to the *Chronicles*, "in a small house near the depot, belonging to the railroad."[117] Schooling for African Americans was entirely novel; for many years, teaching blacks to read or write was forbidden by Georgia law. "In Georgia, if a white teaches a free negro or slave to read and write, he is fined 5,000 dollars, and imprisoned at the discretion of the court," reported the executive board of the Anti-Slavery Committee in 1841. "If the offender be a colored man, bond or free, he is to be fined or whipped at the discretion of the court. Of course a father may be flogged for teaching his own child."

Early schools, both black and white, were typically small one- or two-room affairs, often located in rural neighborhoods. These schools were sometimes sponsored by churches, towns or even individuals. Some schools, such as the Brantley Institute in Senoia, were larger.

"The Brantley Institute was a brick building, actually in the middle of the block between what is now Seavy Street and Clark Street," remembered Paul McKnight of Senoia in an oral history. "I have pictures of the school, before it burned. That would have been the mid-1940s, I guess. It actually burned twice. There had been a clapboard school building on that same lot."[118]

The school had first through eleventh grade, McKnight said. "We had so few students at the Brantley Institute that they couldn't afford the teachers they needed. There were only twelve people in my class when I graduated."

Despite the school's small numbers, it amassed enough students for sports teams like basketball and baseball, playing against regional rivals, such as Alvaton and Starr High School in Turin. "And we finally got a lunch program, just before I graduated," said McKnight. "This was in the early forties. They employed a Miss Pollard, who lived out in the country. She was quite a cook. She canned some at home and put that in with the food. I can remember smelling that food, and I had to go home to eat! But that was some aroma coming out of that basement."

The school had "some of the best teachers in the world," said McKnight. "I will never forget two teachers I had that were first cousins. They were both named Mann, Elizabeth and Emma Lou....They made me think."

His most vivid memory at Brantley Institute was when the students were all called into the auditorium for a grave announcement.

"A Mr. Ford was principal at that time, and he called us all into the auditorium like he did every Monday morning. But I remember going

Totsie and Paul McKnight of Senoia recalled when Senoia was a booming town with its own newspaper, bowling alley and movie theater.

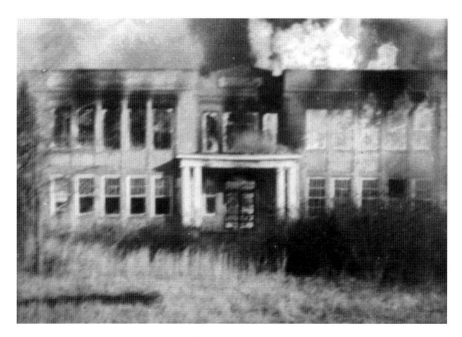

The Brantley Institute in Senoia, catching fire for the second (and final) time. The school was located along Seavy Street.

in there and him having that radio on stage, and he played the president declaring war on Japan. I was a junior so I thought I wouldn't ever have to worry about the war. But two years later, I was serving in the infantry."

Every Coweta community had its own school at the time. Alexander Stephens Academy served Roscoe; in the mill villages on Wahoo Creek were the Arnco and Sargent schools; in Newnan were the Atkinson Grammar School, Elm Street School, Newnan High School and many other schools; other schools were at Dresden, Bethel, Bethlehem Church, Forksville, Farmer's Store, Elim, Corner Branch—the list goes on.[119] As roads were paved and transportation improved throughout the county, schools were consolidated throughout the mid-twentieth century, resulting in fewer and larger schools.

Schools for African American students in Coweta County included Brown High in Moreland, the Booker T. Washington School in Roscoe, the Grantville Training School, Ebenezer School, the Howard Warner School, the Pinson Street School, Central High School and the Rosenwald schools, such as the Walter B. Hill Industrial School in Turin, which now serves as city hall.

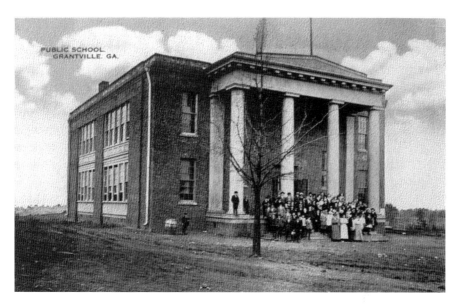

The Grantville public school, built in 1910, was typical for small-town schools of the early twentieth century.

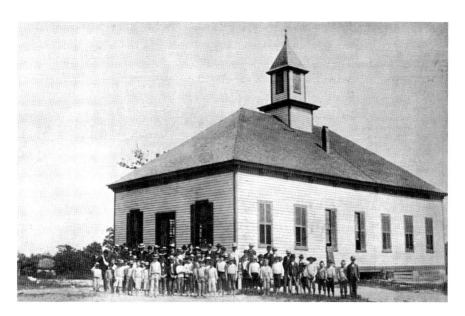

The Male Academy of Newnan. Now serving as a children's museum, the building was constructed from the original Methodist church, located at the corner of College and Wesley Streets, becoming a school for boys in 1883.

A class photo taken in 1928 at Atkinson Elementary School on Nimmons Street in Newnan.

Local advocates for the education of black youth were inspired by the example provided by a former slave, Booker T. Washington, with the establishment of the Tuskegee Institute in Alabama. Built on the grounds of a former plantation, the institution stressed the principle of self-reliance and focused on vocational education and practical skills. In 1907, a "Presbyterian colored school modeled after Tuskegee was built in Newnan by Dr. B.L. Glenn and wife at a cost of $3,500, with Lawrence Miller for principal," noted the *Chronicles*. The school, eventually named McClelland Academy, located on Duncan Street (Richard Allen Drive), had roots extending back to 1889, when the first class of 45 pupils were enrolled as part of a Presbyterian mission. By 1901, there were 148 pupils, ranging from ages six to thirty-eight. By 1904, enrollment had grown to 221 students.

"McClelland Academy is modeled after Booker T. Washington's idea, having for its object the lessening of vice and crime by eradicating the deep-seated superstitions and dispelling the dense cloud of ignorance that overshadows these people, and by giving them instead a thorough fitness for satisfactory, honest, and faithful service in all the ordinary pursuits of life," reported the *Newnan Herald and Advertiser* in 1907.

"Yes, they had church schools, like that private Presbyterian school, that's where the elite blacks went," recalled Sara Clay Williams in an oral history interview. "At the McClelland Academy, the children would come from Franklin and Grantville and from all around and stay in the dormitory, and sometimes they would filter out into the community and stay with people in the community."[120]

She said having an upper-class school on that side of town led to some envy between different local black communities.

"That made a difference between Chalk Level and Rocky Hill," she said. "We had this big, fine school over here."

But it wasn't a public school. Brown High School (1933–46) on Harris Street in Moreland is often recognized as the county's first true public black high school, teaching students in first through twelfth grades. Classes included English, math, social studies, home economics, agriculture and shop. Brown High School was established by Sarah Fisher Brown and named for her. Brown had graduated from Spelman College, received her master of arts

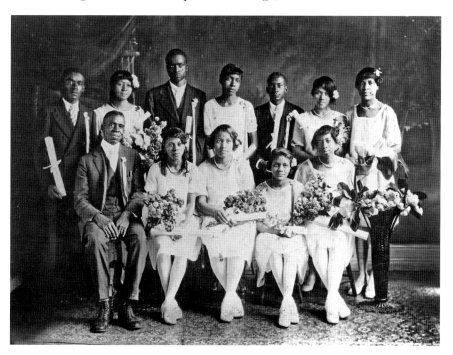

McClelland Academy, located on Duncan Street in Newnan, was a private school for African American students. The class of 1929 is pictured here. From left to right are (*seated*) the Reverend Franklin Gregg (principal), Katie Lee Neely, Willena Thompkins, Thelma Williams (Harris) and Pearl Stargell; (*standing*) Joe Woods, Leila Hines, Tommy Dallas, Jennie Shirley, John Dodds, Sallie Kate Terrell and Lola Smith (Evans).

degree from the University of Chicago and did further graduate work at Harvard University and the Hampton Institute. The *Chronicles* included this description of her:

> *One of the county's greatest (measured by Christ's rule—"He that would be greatest among you, let him serve.") is Mrs. Sarah Fisher Brown, industrial supervisor of Negro schools, who as a teacher in these schools did such faithful and remarkable work for a number of years as to win the respect and friendship of all who took note of her work and that respect her to her present work which is doing more than any agency known to the writer to make good and useful citizens out of Negroes. She was born in LaGrange Troup County where she attended successively the common and high schools then going to Spellman [sic] College in Atlanta.*
>
> *She is the mainspring of the Colored Teachers' and Farmers' conference which has been held each spring for six years, under the auspices of the County Board of Education and the state Extension Service, with exhibits of work done by the industrial classes of the Negro school, demonstration of improved methods of teaching, and discussions of improved methods of farming with exhibits of farm products of all kinds. The value of the conference can hardly be overestimated.* [121]

Brown's reputation drew students not only from Moreland and Grantville but also from Newnan and other parts of the county. The first class graduated from Brown High in 1933 with only five students, but the school quickly grew. The last graduating class was in 1946, when the school was consolidated with the Grantville Training School.

Like other early black schools, the emphasis at the Grantville Training School was primarily vocational education. In operation until 1955, the school offered a range of extracurricular activities, including Tri-Hi-Y Club, Hi-Y Club and Drama Club. The enrollment averaged about three hundred. Students in grades one through three were taught in an army barracks behind the school; other students were instructed in the main building. The principal at the school often held a four-year college degree, but most teachers at the school held two-year degrees. Students recalled in the *Coweta School Days* book that "most kids dropped out of high school, so the graduating classes were usually no more than 15 to 20 students."

"You had black people living out in the country, where they had the fields and all of that was going on. They weren't getting what we got in the city," recalled Williams. "Half of them didn't go to school. They had a few black

schools out there in the country. But those children could only go to school when cotton time wasn't there. If they had to go pick that cotton, they couldn't go to school. So it took them a long time. Half of them didn't ever go to high school. And the men they were working for did not allow them to come out. It was more discouragement than encouragement. I know one family that did not allow the children to come out for school, and they would be back there making that whiskey for them and doing all kinds of different things." The disparity often led to some tense feelings between blacks who lived in the rural areas and those who lived in town, she said.

In Newnan, at 55 Savannah Street, was the Howard Warner High School. The school was named for Professor Howard Wallace Warner, a graduate of Clark College in Atlanta and Fisk University in Nashville, Tennessee, who taught at local black schools for many years. Approximately 250 students were enrolled each year at the Howard Warner School. "The building was first heated by wood burning stoves and later by radiators," Michael Strong and Nina Wilburn wrote in *Coweta School Days*. "A few yards from the school was a library for the black community."

Students studied social studies, home economics, English, biology and even French and Latin, as schools for black students eventually began to shift away from the purely "practical" vocational education that had dominated black schools in the South throughout the early twentieth century.

"The local black schools were good, but they were separate from the white schools, and the black people were always trying to 'level up' with the white schools," said Williams, who taught in Coweta County—at both segregated and integrated schools—for thirty-four years.

Williams remembered going to a Methodist church school when she was young. "It was kind of little school; it was all we had to really go on. It didn't have no real books, but we did have the Bible."

When she got older, she remembers the church school "did acquire some literature," although it "wasn't brand new." She recalled that when she was young there were some "good white folks" who would pass along "little books and things like that" to black youths. "I would read to come up equal with them and try to keep our standards up," she said.

They taught "no history at all, that I remember," even when she began teaching school herself. Geography and science were also not generally taught.

"The children didn't know anything," she said. "We had vocational training, vocational schools in our black high school. We didn't have science and all that, but we could learn how to fix cars and things like that….It was separate and unequal."

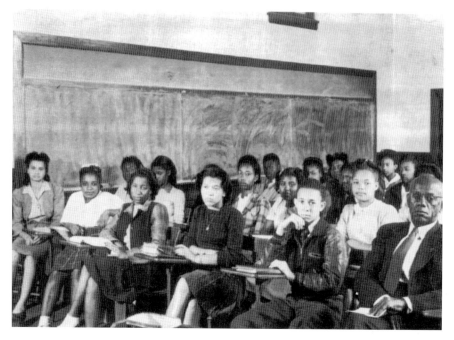

Professor Howard Warner (*far right*) and a class of high school students at the Howard Warner High School on Savannah Street in Newnan. This photo shows the class of 1944.

She wanted better opportunities for her daughter, Angelena, when it was time for her to go to high school in the 1960s. And too many years after the Supreme Court struck down "separate but equal" in *Brown v. Board of Education*, she finally got that chance. "Our community has adopted a school desegregation plan," Coweta School superintendent O.P. Evans announced in 1966 by memo. "We will no longer have separate schools for children of different races....It does not matter whether the school was formerly a white or a Negro school."

During this so-called Freedom of Choice transitional era of the late 1960s, Williams said her daughter was "the first black girl to go to a white school, the first black to graduate."

"I started going to Newnan Junior High School," recalled her daughter, Angelena Scruggs. "The building is gone now, but I remember there was a science lab in the basement. The building covered a whole block, three stories. How could I forget it? It was the beginning of my real education."[122]

"She got a good education there, but the trauma was terrible," said Williams.

"I had to fight through some generalizations," said Scruggs. "And there was a lot of ostracization. I was ostracized a lot....With my being black, no one sat with me at lunchtime, and no one stood with me in the hallway." She said it also meant she had "no boyfriend" since all the boys at Newnan were white.

"But I got along with everyone relatively well," she said. "I had some talents, and I think that made me a little bit more popular with some people, plus I was a pretty smart girl. I wasn't what you would call totally academically developed at the time, but I got plenty of help from some white teachers."

Paul McKnight, who had become chairman of the Coweta County Board of Education by the time of integration, remembers that the county was "probably 40 percent black and 60 percent white."[123]

"One thing that I remember at that time from serving on the school board—our office was in what is now known as the government building, a block off the square. People were lined on the streets. I can remember being threatened, taunting us as we were walking down the street....I don't remember how many there was. It was all who could sit or stand, and then on out the street."

McKnight said there really was no choice but to integrate the schools. But many local residents resisted it to the end.

"It was a very difficult time," McKnight said. He remembered that everyone who supported segregation put green lights up on their porches. "It was mostly people who had less education, so to speak. They were just defying the law."

McKnight said he and his wife, a Lebanese Catholic, had experienced plenty of discrimination and hatred, so he knew what was coming.

"It was really hard being a Catholic in Newnan, Georgia," recalled his wife, Totsie McKnight. "You were discriminated against. I remember in eighth grade I was told by my teacher to explain the Catholic religion to the class. How do you do that? I started shaking in my boots. I can remember it even now. My daddy was so upset about it."

"We went to East Coweta, and I remember people marching outside, near Highway 16, with signs protesting the blacks being in school with us," recalled Totsie and Paul McKnight's daughter, Margaret. "They were saying they weren't going to go to school with it being mixed. Our teacher just pulled the blinds down and shut the windows. We were trying to carry on class with all that going on. That's my memory of it."

Steps toward integration had been happening for years, even when Ellis Arnall was serving as governor in the 1940s. At that time, Arnall made the

controversial decision to enforce a Supreme Court ruling to do away with separate white voting primaries.

"When the court, the highest court in the land, said that we could not discriminate against our black citizens, I had the opportunity, after the courts had spoken, had I wanted and advocated defiance of the court, to control Georgia politics for the next forty years...by simply saying, 'To hell with the court,'" Arnall recalled.

It would have been the easy choice, in line with what the other southern governors chose to do. Arnall went the other way.

"We had dropped the voting age to eighteen; we'd done away with the poll tax, so immediately there became a great surge of Negro participation in our primary and election....I defied the southern traditions by adopting the court's views as my own."

He paid a steep political price. Arnall said he became "an anathema." "That's where I started to lose some of my local popularity."

Eugene Talmadge seized upon the issue and nearly rode it back into the governor's office for a fourth term. Although elected, he died before he could take office, leading to the infamous "three governors" debacle.

When Arnall tried to run for the governor's office again in 1966, he was defeated by Lester Maddox, an ardent segregationist best known for brandishing an axe handle to keep black customers out of his family restaurant in Atlanta. Maddox painted Arnall as sympathetic to the black cause and to integration.

Arnall said he saw himself as a man maybe just a little ahead of his time:

I was brought up in a system which had segregation of the races. In those days, you had toilets for whites and toilets for blacks. When you went to the movie theater, the blacks sat in the gallery, the whites downstairs. We had complete segregation in the schools and everywhere else. That was the system that was in effect and that was the system under which I grew up. I did not take any legislative position as to the races in my administration, because I knew that if I had come out for first-class citizenship for the blacks, I would have been so handcuffed that I could not have done the job which we wanted to do for Georgia....Timing is the important thing in politics and in life. There are times when you can do things and times when you can't....It would have been suicide...

I've always believed there's nothing wrong with government that a good dose of democracy won't cure. We in Georgia have the largest population of blacks of any state in the Union. About a third of our people are black,

they're citizens, they pay taxes, they work and they're entitled to vote and participate in government. It is somewhat of an accepted attitude, although bigotry and racial intolerance die slowly.[124]

Maddox demonstrated just how hard bigotry dies when he urged Coweta County residents to defy a 1970 court order that would finally bring full integration to the local school system, perforce. Those who considered this an imposition rallied under the words "freedom of choice" (echoing an earlier generation's cry of "state's rights"), but even fifteen years after the historic *Brown v. Board of Education* decision, Coweta County schools still weren't fully integrated. Governor Maddox spoke at Newnan High School's Drake Stadium that September. "There is nothing in the U.S. Constitution that says where you send your child to school," he told a crowd of 2,500 locals. He said a fight against integration was a fight for "God, country and freedom."[125]

Schools were finally integrated, nonetheless, bringing an end to over a century of local segregated schools.

"The law was there," said McKnight. "We had been to Washington, we had tried to ignore it but our attorney was satisfied: the law was there."

"I think my class felt really sorry for the blacks their senior year," said Margaret McKnight. "I can't imagine not getting to graduate from your own high school. That was a very difficult time, and they lost their school."

She said that students in the school continued to self-segregate, however.

"It just happened. Blacks went this way, and whites went this way. You could sit anywhere you wanted to in the lunchroom, but they sat in their corner and we sat in ours....It was obvious."

Teachers tried to counter this inclination with seating charts and sports, especially, she said.

"We lost one of our state championships because of a misunderstanding," said Margaret. "We were staying at a hotel in Macon. The blacks on the team thought they had been put on the wrong side of the hotel. In their minds, they were put on the back side of the motel. So in the game, in the tournament game, they would not throw the ball to me or to any of the other white girls on the team. And we lost the championship game.

"I was wide open, and so I asked them. Why? I didn't even know what was going on. I was oblivious to anyone who even thought like that. It didn't even enter my mind....I was not aware."

"There was a little clash every once in awhile," said Angelena Scruggs. "There was a lot of excitement and a little fear during my senior year when

they finally brought all the kids over from the black high school to the white high school, and I had to be in the middle of all that, with my black friends from my church and my neighborhood, and my white friends from school."

She finally got a boyfriend, she said. But she still had to fight against some assumptions.

"My counselor didn't put me in the college prep program," said Scruggs. "She didn't realize that I came from an educated family. That it wasn't a matter of whether or not I was going to go to college—it was which college. But they would put me in the classes with all the slow white students, and then they wondered why I excelled. Because I could read."

Her mother had similar problems as a teacher moving from the black schools to an integrated school system. "In certain situations you knew you couldn't say certain things," recalled Williams. "You don't put yourself in a position to get slapped.…Yes, they would slap my face.…So I learned…there was no need for me to take it on."

Many times white teachers were clearly favored, she said. "My principal was very favorable toward the white women," said Williams. "There never was a Teacher of the Year who was black while I was teaching school, and I knew there were many smart black women who could outsmart any white woman in that school. But they could never be Teacher of the Year."

She said favoritism was often apparent in class assignments.

"They set up three different sets of children," said Williams. "They had a top group, a middle group and a low group. And they put me in with the slow groups, because no white teacher wants to teach the slow children."

The "low groups" were often filled with black students from schools that had not prepared them for integration.

"Those groups were more black than white, because they are underprivileged and deprived," said Williams. "It's still the same way now. I know it's like that now."

Williams said she wasn't given any choice about the groups she had to teach.

"You were assigned. They didn't give me a choice," said Williams.

There were some teachers who wouldn't even take the lower class white children.…They would put the lower class of white children in the black teacher's room.…You could see it, you really could.…At one time I thought about suing the county, for keeping me in there with those children for so long.…It takes a lot out of you. It takes everything you have.…It still bothers me to hear a grown person say, 'I can't stand that child.' And I would hear the white teachers say that, I would wonder, what do they really

mean? It wasn't the child they couldn't stand. It was the family. Wasn't that something, to take something out on a child, something that you dislike about their parent? But they did, though.

But I'm a helper. I like to help. I figured I needed to do the best I could.[126]

Scruggs said that those white parents who had the money avoided integration by sending their children to the newly built Heritage School on Highway 29, just north of town.

"They built themselves a school on Highway 29," she said. "And they moved their children out there to it. After that year of total integration, that's when the Heritage School came up."

Some of the talk around town at the time reminded Williams of things she hadn't seen and heard since she was a child. "I heard one parent tell his son, 'You don't have to go to school with those niggers.' I heard it. He said, 'You don't have to associate with those children.'"

It brought her back to something she had seen as a small child, on her front porch.

"When I was a little girl, there was a man who lived at the top of Ray Street, a Mr. Kilgore." Ray Street was named for the same Ray family who donated the land decades earlier for the nearby—but still at that time "whites-only"—Ray Park. "Mr. Kilgore was a member of the Ku Klux Klan," Williams said. "I remember one afternoon we were all sitting on the front porch and after a while here comes these three mounts, all with these hats on, all coming down Ray Street. We were looking at the horses, there were three of them, coming down the street with their masks and everything on. They rode a lot at night, but this was in the daytime. They came up in our yard. He walked his horse up on our front porch. We had to go in the house."

Her daughter remembers one of the last Klan parades that occurred "just before we had total integration."

"None of the local people were recognized," said Scruggs. "But I remember them marching through downtown Newnan. This dichotomy seems to always exist. This idea that we are doing something to the white people. But we are not doing anything to them. We are just being American citizens."

Williams said that now things "aren't done so openly." But she said that she "still knows when it's happening, because I've encountered it too many times."

Scruggs said she still sometimes finds herself in situations that make her feel uncomfortable.

"It's something some people have in their head. Maybe they still have some anger over some people they lost in the Civil War or something. Whatever. They need to get themselves right with the Lord. I think it's a major control issue. It's who runs the show."

Whatever it is, Scruggs said, "We really don't know, and we really don't care anymore."

For a long time, she said, "there was a cloud over Newnan."

"Really it was over the whole state of Georgia, when I was growing up," said Scruggs. "You could only talk to other black people in the downtown areas. You weren't supposed to look at white people in the face. We still had colored and white water fountains."

She remembers learning to swim when she would visit her cousin in Dayton, Ohio, because she wasn't allowed to swim at the pool in her own neighborhood.

"I couldn't go to the swimming pool in my own backyard. A city swimming pool, right down the street, within walking distance. I couldn't go to it. Before integration, I was always the one standing at the gate, looking in," she said. "I had to learn to stroke and do laps in Ohio."

Sara Clay Williams and her daughter, Angelena Scruggs.

Sometimes when she looks back on all that history, "I'm amazed I'm still here," she said.

"Some of that animosity you pick up on, it exists….And all of it is unfounded."

Scruggs said that many black people living in Newnan and Coweta County have opportunities previous generations were never afforded. They are "comfortable" and "have good jobs." But many of the same issues persist.

"In actuality, we are living for the first time, free of major encumbrances—the ones we had to go through," she said. "They are just trying to enjoy their lives, and I don't blame them."

In a world often driven by difference, demagoguery, and fear, we

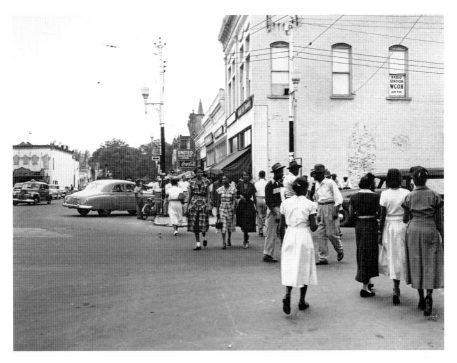

The Newnan North Court Square, taken from the Virginia House corner. James Mansour said in his oral history that he doesn't think the Mansour's store would have lasted as long as it did without the business of its African American customers.

must strive to understand and embrace each other, even when it's difficult, she said.

"You cannot judge a person by their skin color," she said. "Most people who meet me don't know I'm from Newnan, Georgia. I don't have a Southern accent. I don't seem that way.

"This is something we've got to work on—all this infighting, everyone always wanting to have it their own way. Because in America, that is what makes us great—our differences, our diversity. This is what the world admires about us. This is the way everyone wants to go. I think Americans, both black and white, are too hard on themselves. We are really leading the way in the world."

8

"WON'T EVER GIVE UP"

I saw my first movie in Newnan," remembered Ollie Evans. "I remember the silent movies. My brother and I had never seen a movie. So my brother decided he would take me to a movie one day. We sat up close to the front. The trains were coming right at us. We jumped and screamed!"[127]

The first movies were screened in arcades, photo studios and drugstores—even in tents.

"In Senoia there was a vacant lot when I was growing up where people would come in, and they would have a tent show," remembered Paul McKnight. "They would have this place you could sit like circus bleachers, and you'd sit in a tent and watch that movie. On a Saturday night they'd pack 'em in. There was no television in those days and very few radios."[128]

"In Newnan, we had the Alamo and the Gem theater," recalled Lillian Stripling Gardner. "That was about the only entertainment you had in a small town. Those theaters were both on the west side of the square, and they had one at one time over on the south side."[129]

Theaters like the Alamo were strictly segregated, with a "colored" section in the balcony.

"We did try to have our own theater, over in our part of town, on Robinson Street," remembered James Gay. "At one time I was going to school to be a projectionist. This theater was black owned and operated and showed black movies. Of course we did show a lot of white movies, too. But it was mostly black movies. The building is still there."[130]

He said the theater only lasted "five or six years—not long."

The Gem Theater was located on Newnan's West Court Square and dated back to the silent film era. The 241-seat theater was smaller than its neighbor, the Alamo Theater, which featured a segregated balcony section.

Downtown Senoia, at the turn of the twentieth century. Note the public water well.

"This fella had an idea he could build a building there and pull some old seats out of an old building, I don't know. They weren't cushioned. They were slatted, wood seats. And he was working in Atlanta, and the movie was open only at night. And sometimes he didn't come down here at all. He didn't run a good business. People would be down there waiting for the show, and he wouldn't be there. Sometimes he would show up, and the big crowd had done come and gone."

The biggest movie event by far during the mid-twentieth century was *Gone with the Wind*. The film had its world premiere in Atlanta in 1939.

"I stood in line for two hours when *Gone with the Wind* first came to Newnan," remembered Evans. "We were the first ones in St. Charles to have the *Gone with the Wind* book. It was a 1936 first edition. I wish I knew how many people read that book. So many people read it that it had started to come apart, so I took each page and glued it back in."

"I remember we bought our tickets to see *Gone with the Wind*, and we were sitting there watching the movie, and we saw some Yankee soldiers come onto the screen," remembered Totsie McKnight, "and there was a man in the audience who started cussing at them. He started shouting, 'You damn Yankees! Get on out of here!' They had to ask him to leave."[131]

"That movie has made more money than any movie that's ever been made, if you adjust for inflation and the ticket price," said Herb Bridges of Sharpsburg. "When that thing came out, the top ticket was $1.50 on Broadway in New York City. And you can imagine, when *Star Wars* came out and beat it, it was like six dollars, I don't know what it was. It just keeps going up."[132] He mused:

> *Who knows why the book became so popular? I think it just came out, evidently, at a time when America was just ripe for that kind of story. It just caught the American public, and then it spread to the world. And when it became a movie, I don't think up until that time that there had ever been as big a premiere anywhere as big as that one was. It was just such a big book; it had sold so many copies to so many readers.*

The decision to have the world premiere in downtown Atlanta at the Lowe's Grand Theater just made sense, Bridges said, since the novel and film were set in the Atlanta area.

"They'd had premieres in Atlanta before, but never like that," said Bridges. "The public clamored for movie stars….It was just a tremendous event. The movie stars that were coming into Atlanta for that—gosh, it

was unheard of. And all the people came out of the wayside to see those movie stars."

He likened it to the 1996 Atlanta Summer Olympic Games.

"We think the Olympics in Atlanta attracted a big crowd, and it did. But if you compare the population of Atlanta when the Olympics came and the population of Atlanta when the premiere of *Gone with the Wind* came, why the premiere of *Gone with the Wind* would just blow it away, with all the people that came in.

"The movies were just so popular in the '30s and the early '40s," he said. "It was just a big, glamorous event, with all the society and all the parties and all the junk that was sold."

As for Bridges himself, who saw *Gone with the Wind* as a ten-year-old child in the 1940s, "it made no impression on me whatsoever."

It wasn't until much later, when the film was being trotted out again to celebrate the Civil War centennial anniversary, that he became drawn to it.

"It was sometime in the '60s, about '64 or '65," recalled Bridges. "I don't know why. Why do you pick up golf? Why do you start collecting stamps? Why do you start collecting coins? Do you know? Why did I start collecting *Gone with the Wind*? I don't know. It just kind of fascinated me. How do you say it? The movie was something special. They brought it back in 1961 for the Civil War centennial, and it was kind of a thing. So I just started then."

Bridges said that back when Metro Goldwyn Mayer owned the rights to the film "they would only bring it around every seven years." People didn't own VCRs, computers or DVD players, so there was no way to see the film in-between times.

"So that made it special," Bridges said. "They knew how to milk that turnip, or whatever you want to call it, for all the money they could get out of it. They were smart to do it, because everyone was anxious to see it again. And they paid big bucks. The movie company had to do practically nothing. They would create some new posters with some new artwork, that's all they did. Just show it and make your money."

Bridges said that when he was working as a mail carrier around Sharpsburg he thought it might be fun to see if he could begin to collect some *Gone with the Wind* memorabilia through the mail.

"Well since I was working for the post office then, it was no big deal," he said. "It was fun to write and try to get these things."

He'd read that the book had been published in forty-seven countries and translated into forty-two languages. Bridges thought it might be interesting to see what the book looked like in places like Germany or Japan.

"I just thought it would be fun to get one from each country and see what it looked like," Bridges said. "I couldn't read it, but that didn't matter. It just became fascinating to me."

After he collected all the foreign editions, the next logical step seemed to be to collect all the movie poster variations.

"What does a *Gone with the Wind* movie poster look like from Italy?" Bridges said. "It would look different from ours. What about one from Germany?"

When word started to get around about his quickly growing collection, Bridges began getting calls from the "Kiwanis Club, the Rotary Club, all those people," he said. "After you get all that junk, the garden club is calling you and saying, 'Give us a free program!' So I began to do that, and it was fun. But it just grew and grew and got out of hand."

Eventually, Bridges's "junk" became generally recognized as the largest *Gone with the Wind* collection in the world.

"I was having a good time. I went to Japan on two different occasions with an exhibit. My collection toured Japan for a year, and the next time for a year and a half, and of course, they had to send me over there with it. And then I had an exhibit in France one time. I had one in Canada. It was just a good hobby, because of all the places, all the people.

"They have read the book. They have seen the movie," said Bridges. "So you tell them something about Scarlett O'Hara, and they were happy."

Many did not realize that Scarlett and her beloved antebellum Tara plantation were fiction, he said.

> *The Europeans began to come here to America to tour, you know. And if they came to Atlanta, they would want to see Tara. Where is Tara? Where is Scarlett buried? I want to go see the family cemetery. Margaret Mitchell had just made it all so believable. She was such a talented storyteller that you believe that those people actually existed.*
>
> *She did a great deal of research. Like with her battles, she knew the names of the generals who came through here, both Confederate and Union. All of that is quite factual. But as far as someone named Scarlett O'Hara or Rhett Butler or Tara—all of that is just pure fiction.*

That never stopped the local tourist industry from capitalizing on *Gone with the Wind*, he pointed out.

"Of course they say that, 'We got Tara over here! We can show you right where Scarlett got on the stairs and shot that Yankee soldier, right in this house!' And the tourists are so gullible they'll believe it. But no, *Gone with the*

Dunaway Gardens opened May 18, 1934, on Roscoe Road, Highway 70, in north Coweta. The gardens were touted as a place of romance and charm, and southern belles were often photographed in trappings reminiscent of *Gone with the Wind*. The gardens covered twenty acres of Wayne P. Sewell's family land.

Wind is fiction, just like Margaret Mitchell kept saying. There never was a Tara here."

So why not build one? One such effort centered on Dunaway Gardens in Roscoe, where at one time there were plans announced to reconstruct the original façade from the film. The headline in October 1986 read "Shades of Tara in Coweta County":[133]

There were no plantation homes in Coweta County of the MGM Technicolor grandeur of Scarlett O'Hara's Tara, but some came close—such as the A.B. Calhoun home, formerly located on Greenville Street, built in the 1850s. The home was demolished in 1955.

A restoration company has announced plans to spend $20 million to construct a Gone with the Wind *attraction in Coweta County.*

The scene will use the Tara façade from the 1939 movie.

Dunaway Gardens Restoration, Inc. announced plans…to build the attraction in a 64-acre rock garden near the Roscoe community in the west Georgia county…

The reconstructed Tara will be the main attraction, which will include a working plantation.

Those plans never materialized, and the façade sat in storage for decades.

"We never built it, which was always a mistake, I thought," said Bridges (although Dunaway Gardens was eventually restored to its former glory, serving as a scenic backdrop for many weddings and photo shoots). "Why in the world didn't someone build the thing? Charge them five dollars to go through it and make all kinds of money. But it never came to be."

The Hollywood façade was unlike any Georgia plantation that ever actually existed, he said.

"Of course Hollywood glamorized it so much," Bridges said.

"If you read the book, really Scarlett just had a functional farmhouse, but movies don't want to show functional, they want to show glamour and all of that," he said. "Ms. Mitchell, she stated that there never was a house in North Georgia like the one they showed in the movie. Sure, there may have been some like that in New Orleans or maybe in Savannah, where all the aristocracy and the wealth was, along the coast. But not up here in the farmland of North Georgia.

"But it just looked so believable in the movie, you know," he said. "And now you have this visual representation of it, no matter if it was completely fake. And I think people were greatly impressed, and they just really fell in love with the idea. But that's Hollywood. That's what Hollywood sells. Hollywood doesn't sell reality."

One Coweta native who did try to peddle to Hollywood what he claimed was a more realistic depiction of the Deep South was never embraced by southerners in the way Margaret Mitchell was. There was nothing grand, romantic, chivalric or noble about the South as depicted by Erskine Caldwell in the classic novels *Tobacco Road* and *God's Little Acre*, both later made into major Hollywood films. Caldwell, born into poverty to a minister in Moreland at the turn of the century, spent a career spinning what became known as the *Tobacco Road* southern stereotype, based on his early experiences in Coweta County and other places in Georgia and the South. Southern farmers and millworkers were portrayed as ignorant, backward, greedy, hypersexual, filthy and comically tragic—perfect fodder for public ridicule—and a complete inversion of the formerly dominant, highly romanticized "Lost Cause" archetype portrayed on such a grand scale in *Gone with the Wind*.

If unappreciated in the South, Caldwell's novel *Tobacco Road* was an immense hit everywhere else, eventually becoming a successful Broadway play and Hollywood film. *God's Little Acre* soon duplicated that success, making the Deep South a punching bag for decades, played out again and again in pop culture detritus like *Li'l Abner*, *Ma and Pa Kettle*, *The Beverly Hillbillies*, *Green Acres*, *Hee Haw* and, of course, *The Dukes of Hazzard* (based on the 1975 film *Moonrunners*, also filmed in Coweta County). The negative stereotypes these shows and films engendered and encouraged are still found largely socially acceptable today, much to the chagrin of many local people.

"One of the Moreland mayors threatened to tear the Caldwell house down. He said it was a house of pornography," said Sarah Haynes, herself a former Moreland mayor.[134]

His books were known around here as "dirty books," she said. "A little thirteen-year-old boy bought a tape because it had Erskine Caldwell on it and

Left: Sara Threatt Haynes served as the mayor of Moreland for several years in the late 1980s and early 1990s and was instrumental in the relocation of the Erskine Caldwell birthplace to the downtown square.

Below: Erskine Caldwell, the famous author of *Tobacco Road* and *God's Little Acre*, was born in this "Little Manse" near Moreland, which currently serves as a museum. Pictured here are, from left to right, Jane Young Carmical, Esther Carmical Walthall, Nancy McKenny Hemphill and Reverend John Lind Hemphill of the White Oak Associate Reformed Presbyterian Church.

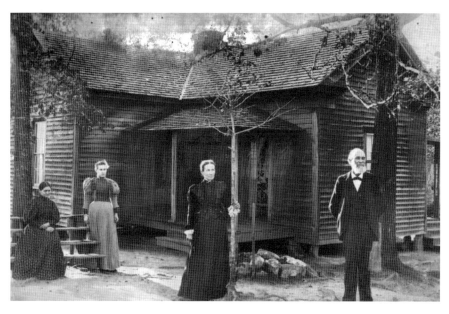

carried it home to his Ma. She thought she'd sit down to listen to it. She said it was awful. She said her husband came in the room, and she was ashamed."

Caldwell's father "was real ugly about his writing" since he was a Presbyterian minister and his mother a schoolteacher. "He was ashamed of his son's books and didn't want him to do it," said Haynes. "But I think when the money started coming in he wasn't quite as ashamed as he thought he was."

Under Haynes's leadership, the Town of Moreland decided to capitalize on Caldwell's fame. They brought the decaying Caldwell house into town and plopped it down in the center, restoring it and turning it into a museum.

"We felt like it was worth saving," she said, even if it was controversial.

A sensational, grisly murder that occurred in Moreland in 1948—historically notable for being an early instance of testimony from poor black men leading to the execution of a politically connected, landed white man—was also turned into a bestselling book and a movie in the 1980s, *Murder in Coweta County*. In the years since, the town has been constantly under the lens—right along with Newnan, Grantville and Senoia, home of the hugely successful *The Walking Dead* TV show on AMC.

The new economy for Coweta County seems increasingly to be tied to the film and television industries, complementing the booming medical, housing and retail sectors. The seismic economic effect the industries are having on the state of Georgia is undeniable, said Craig Dominey, Camera Ready program manager and senior film location specialist with the Georgia Film, Music and Digital Entertainment Office.[135]

Just look at all the funny yellow signs dotting the landscape, Dominey said.

"That's kind of a visual sign that the film industry is booming here," said Dominey. Films like *Fast and Furious 8* and *The Hunger Games* never use the actual names of the films on the directional signs for crew and extras, but "people always seem to find out, anyway," he said.

There have been 248 film and television productions in Georgia since the office began counting them, with a total economic effect of over $6 billion. Most of that has come within the past decade. Senoia has been intimately involved in Georgia's film business from the very beginning, with Riverwood (now Raleigh) studios attracting such early productions as *Fried Green Tomatoes* and *Pet Sematary II*.

"I remember it used to be nothing but pine trees, taking film productions on the drive down to Senoia," said Dominey. "It's a lot different now."

The Walking Dead spends about $60 million per year on production, Dominey said. "Half of this is on goods and services," he said. "Half of the payroll is in turn spent on goods and services, rents, etc."

In 2007, there were only five or six businesses in Senoia. Now there are over fifty. The number of restaurants has grown from one to seven.

"There's a 100 percent occupancy rate," said Dominey. "There's been $50 million in new/historic-looking infill development in Senoia, creating hundreds of jobs."

It's the kind of business that's good for historic preservation, as well. People have been buying up old historic properties and rehabilitating them, increasing local property values, he said. The 30 percent tax credit has been huge for the state as a whole, too, he said, as film and TV companies have generated an estimated $1.7 billion in direct expenditures in Coweta County. That goes for things like lodging, car rentals, catering, office equipment and other purchases, rentals, gasoline, security and so on.

It's also been a great promotional tool for the state of Georgia, as the Georgia peach symbol is now prominently featured in the credits of so many films. "Even years later, we get calls from people wanting to find these film locations," Dominey said. "We still get calls about *Fried Green Tomatoes*," partially filmed in Senoia.

New studios are building in the Atlanta area all the time, now including Pinewood Studios, Third Rail, the Film Factory, Screen Gems, Tyler Perry Studios and many others. According to the Motion Picture Association of America, the TV and movie industry is responsible for more than 79,100 jobs and $4 billion in total wages in Georgia. "These are high-quality jobs, with an average salary of nearly $84,000, which is 74 percent higher than the average salary nationwide," said Dominey.

Bus tours alone have generated $550,768 in total ticket sales since May 2013, Dominey said. Since then, nearly ten thousand people have visited Senoia to investigate *The Walking Dead* fictional towns of "Woodbury" and "Alexandria." They have directly spent over $250,000 there, he said.

In downtown Senoia, "these days we have a lot of *Walking Dead* fans," said Suzanne Helfman, owner/operator of the Culpepper House, a bed-and-breakfast on Broad Street in Senoia. "But of course that's not everyone. Our typical guest has always been what I would call a historic cultural traveler, someone who loved old homes and old towns. Some of these people have never seen the show, or they've seen it and they just don't get it. I'd say right now we have about a 50/50 mix."[136]

"Walker Stalkers" is the name applied to *Walking Dead* fans who wait for opportunities to get their photos taken with the cast members. Pictured here are Frances Hildenbrand (*left*), Norman Reedus (Daryl Dixon) and Hetty Bishop.

She said it wasn't until about three years ago that *The Walking Dead–*related business "really took off." The town has been the centerpiece for many seasons of the show.

"We are definitely getting people who would not have come to visit Senoia before, but they want to come here because that whole Woodbury thing was based here," said Helfman. "It's increased business for us, from all those fans."

Laura Reynolds, owner/operator of the Veranda, on Seavy Street, said that *The Walking Dead* has offered the town "an amazing adventure."

"It's just been an onslaught," said Reynolds. "We have people from all over the world who are coming to Senoia just to see Woodbury."[137] She said one might expect these fans to be "of a certain ilk." But that has not been the case.

"Oh, no," she said. "We have grandparents and young people and just the whole spectrum. Grandmothers bringing their granddaughters. People who, when you first meet them, you would have no idea that they are *Walking Dead* fans."

Reynolds said a few of the cast members have stayed at the Veranda, but she usually tries to give them their privacy.

"We've had a lot of *Walking Dead* makeup artists stay with us, and we've had several of the stars stay here," she said. "Carl Grimes [Chandler Riggs] and his real father have stayed here, and Andrea [Laurie Holden]. They were friendly. Sometimes I didn't even know who they were."

Laura said her husband, Rick Reynolds, had checked Holden in one day and that she "came down to serve her breakfast, just like any of the other guests." When Reynolds found out who she was, she had her picture taken with her.

"She was very kind. I don't usually take pictures with cast members," said Reynolds.

Helfman, who also served as chair of the Downtown Development Authority for Senoia, said people are interested in other films and television shows with a Senoia connection, but nothing approaches the level of enthusiasm expressed by *The Walking Dead* fans.

"*Fried Green Tomatoes* is popular, too," she said. "People want to see the Travis-McDaniel house [204 Bridge Street] where they filmed that movie, but *The Walking Dead* is by far the most popular right now."

Helfman said she has witnessed fans taking photos of themselves beside the stars in the Senoia "walk of fame" sidewalks. There are stars for films such as *Footloose*, *Lawless*, *Sweet Home Alabama* and many others and for TV shows such as *Drop Dead Diva* and *I'll Fly Away*—but again, it's *The Walking Dead*'s star that grabs all the attention.

"We have a very walkable town. And people just lie down next to the plaque on the sidewalk and get their picture taken with it," she said.

The reach of *The Walking Dead* even extends over to Newnan, where many of the scenes have been filmed. Patty Gironda, owner/operator of Casa Bella bed-and-breakfast on Temple Avenue, said that she has felt a bump from the series, as well.

"Of course we don't get the impact nearly as much as Senoia does," said Gironda. "But Lennie James [Morgan Jones] stayed here. What I knew him from, he was the villain in the movie *Sahara*, about finding Confederate gold in the desert. But we got word that he wanted to stay with us, and I had to sign a non-disclosure statement, saying that if I found out anything about *The Walking Dead* I wouldn't talk about it. So instead I reenacted all the scenes from *Sahara*. He's been one of my most fun guests, I would say. He was charming."[138]

The B&B operators all agree that the effect of *The Walking Dead* and the rest of the TV and film business has been overwhelmingly positive for Senoia and Coweta County. The newest film made in Newnan, *The Founder*, starring Michael Keaton, might even be an Oscar contender, some say.

"The movie industry has been great for our town, and it's only been an asset for businesses like ours," said Reynolds.

So what of *Gone with the Wind* and its highly romanticized version of local history? Undoubtedly the biggest film of its time, have audiences now moved on to other things? Have the people of Coweta County?

"It's fading," said Bridges. "It has reached its peak."

"There are no big *Star Wars*. No shoot-'em-ups. No big car crashes, in *Gone with the Wind*," said Bridges. "A lot of them say *Gone with the Wind* is just a hokey old soap opera love story. The young people have not grown up on that. Therefore, they are not interested. And as long a run as *Gone with the Wind* has had, I don't think anyone could complain."

He said there aren't many "major collectors" of *Gone with the Wind* around anymore. He put up much of his own collection at auction.

"For one thing, *Gone with the Wind* is not politically correct for a large segment of the population," Bridges said. Its depiction of happy, servile slaves speaking a heavy *patois* and smiling broadly as they pick cotton on the plantation is not generally palatable, he admitted.

"In Atlanta, in the Deep South, that's going to be a delicate thing," he said. "In fact, it's often better not to mention it," which means that films like *Gone with the Wind* are generally seen as "of their time" and no longer part of mainstream culture.

"As you know, Atlanta is a different color now," Bridges said. "They do not look with favor on some of this."

He pointed to the fact that when the Margaret Mitchell House was first being established as a museum in the 1990s, it burned twice.

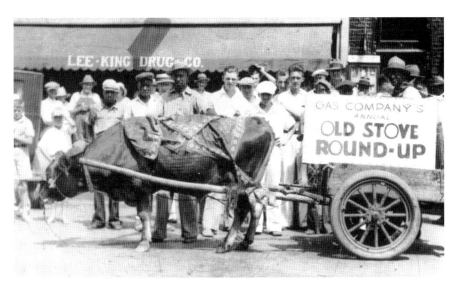

Wilbon Clay's father, Willie Glen Clay, and his sons are pictured in front of the old Lee-King drugstore on the Newnan Court Square during one of the "old stove round-ups" in the early 1930s.

Wilbon Clay, Coweta County's first black county commissioner since Reconstruction, congratulates his successor, Robert Wood, in the chambers of the Coweta County Commission in late 1993.

"So you know that's got to be something fishy," said Bridges. "If they can't establish a museum there and take the tourist dollar, which is the easiest dollar in the world, that tourist dollar....They cannot accept their heritage. I don't think they ever will. They do not want to acknowledge it. They came over from Africa. They were slaves. There ain't no way to get around it. They don't teach it in schools. But that's the only way you can get around it, is to ignore it, and that's a shame. They have moved on so far from that, why don't you just acknowledge it and go on?

"But some of them will not give up," said Bridges, who passed away in September 2013. "They won't ever give up."

Not long after the Civil War, a young man came to Senoia with eleven dollars in his pocket. He had been "set free" after the war by a white man, his father and former master. Unlike his white relatives, he had no property, no useful family connections and little schooling. Like many former slaves,

he sharecropped for a time, but in many ways, he found sharecropping only a small step above slavery. At the age of nineteen, he used the money he earned selling peanuts and axle grease to make his way north, on foot, from Social Circle. In 1878, he found himself in the tiny hamlet of Senoia. The town was in its infancy—younger than he was—and just trying to establish itself, much like him. He continued to work as a farm laborer in Senoia, but he also learned a new skill, one that eventually would carry him to Jonesboro and then on to Atlanta to become Georgia's most successful African American entrepreneur, Atlanta's wealthiest black resident and greatest property owner and the founder of an insurance company that is still in business today. The young man was named Alonzo Herndon. He would soon build a reputation at his shop on 66 Peachtree Street as the best barber in the South, and it was in Senoia that he first learned to cut hair.[139]

A few years earlier, on the opposite side of Coweta County, at the great Chattahoochee River crossing between Newnan and Carrollton, a man built a massive wooden bridge that was considered a technological marvel of its era. Horace King, born in 1807, learned to build wooden-truss bridges as a young slave. King purchased his freedom using funds he earned constructing bridges at every major Chattahoochee River crossing and at sites all over Georgia and the South. After accepting a financial interest in the Coweta/Carroll County toll bridge, called Moore's Bridge, as payment for its construction, King and his family settled for a time on the banks of the Chattahoochee to collect the tolls. He built a factory and mill in Coweta County during this time and designed the elegant "floating" staircase of the Alabama capitol building. After the Civil War, King served two terms in the Alabama House of Representatives. He was recognized as the most respected and successful bridge builder in the South, laying the foundations for the region's initial infrastructure. Some of the bridges built by King and his sons still stand today, over a century later.[140]

These anecdotal "bootstraps" stories, while true enough, were certainly not typical. But they demonstrate that, even in the most trying of circumstances, during a period of history that must have felt impossibly cruel and hopeless for at least half the local population, some dared to envision better lives for themselves. In spite of the seemingly insurmountable difficulties placed before them, when they were routinely ostracized, patronized, taunted, vilified, disenfranchised and stripped of their basic human rights, they never gave up.

Most freed slaves and their descendants did not have opportunities to build bridges or invest in businesses and worked instead as sharecroppers,

day laborers and domestic servants. (Landless whites and bankrupted cotton farmers often worked similar jobs until the opening of the mills at the turn of the century.) But these people never stopped longing for something better: being treated with respect and basic human decency. And if the South has been too long portrayed as a Scarlett O'Hara or a Blanche DuBois—tragic heroines who seem to have lost something essential, never to be regained—perhaps it is time to think of the history of the South in a new way. It is, I would argue, not a tragic narrative about losing something. It is instead a triumphant story of a succession of attempts to *gain something* much more vital than anything that was lost. This alternative narrative tells the story of the people of the South in their ongoing struggle to build—piece by piece—what is central to any credible, modern liberal democracy: a society of equals.

"Let me tell you a story about my oldest uncle, Uncle Oscar," said Wilbon Clay, who in the waning years of the twentieth century became the first black county commissioner elected in Coweta County since Reconstruction.

> *My uncle Oscar grew up with a white guy down there, on toward Welcome. His name was Gene Newman. They come up as boys and played together. Well, Gene Newman went off to school for a time, out of town, and finally came back home. He saw my uncle Oscar, and my uncle hollered at him and said, "Hey, Gene!" And he says to him, "That's MISTER Gene, to you." And my uncle says back to him, "Before I call you 'Mr. Gene,' I won't say a damn thing to you." My papa rode in there with a big, black horse and carried my uncle out of there.*
>
> *Gene Newman later got on the police force. My uncle Oscar said, "You respect me as a man, I will respect you as a policeman."*

"But," said Clay, "my uncle never did call him 'Mr. Gene.'"[141]

NOTES

Chapter 1

1. Schoolcraft, *Archives of Aboriginal Knowledge*, 252–58.
2. *Newnan Herald*, February 1925.
3. Ibid.
4. Anderson, *History of Coweta County*, 14–15.
5. Ibid., 20.
6. Cotter, *My Autobiography*, 185.
7. Ibid., 10.
8. Ibid., 20.
9. Jones and Reynolds, *Coweta County Chronicles*, 59.
10. Ibid., 52.
11. Ibid., 55.
12. Anderson, *History of Coweta County*, 25.
13. Jones and Reynolds, *Coweta County Chronicles*, 775.
14. Candler, "Reminiscences of Life in Georgia, Part I," 36.

Chapter 2

15. Ibid., 37.
16. Ibid., 43.
17. Newnan-Coweta Historical Society, *History of Coweta County*, 13.
18. Candler, "Reminiscences of Life in Georgia, Part II," 110–11.

19. For more information, visit http://www.ferris.edu/jimcrow/links/ VCU.htm or https://en.wikipedia.org/wiki/Stereotypes_of_African_ Americans.
20. Candler, "Reminiscences of Life in Georgia, Part I," 47.
21. Jones and Reynolds, *Coweta County Chronicles*, 599–601.
22. Ibid.,112–18.
23. Ohio Historical Society, "African-American Experience in Ohio."
24. Ibid.
25. Wolak and Wolak, *Life in Coweta County*, 42.
26. Jones and Reynolds, *Coweta County Chronicles*, 374–76.
27. Ohio Historical Society, "African-American Experience in Ohio."
28. Ibid.
29. Ibid.
30. Jones and Reynolds, *Coweta County Chronicles*, 133–35.
31. Baker and Baker, *WPA Oklahoma Slave Narratives*, 162–66.
32. Newnan-Coweta Historical Society, *History of Coweta County*, 12.
33. Ohio Historical Society, "African-American Experience in Ohio."
34. Ibid.
35. Ibid.
36. Lane, *"Dear Mother,"* 344–45.
37. Candler, "Reminiscences of Life in Georgia, Part V," 11.
38. Baker and Baker, *WPA Oklahoma Slave Narratives*, 162–66
39. Ohio Historical Society, "African-American Experience in Ohio."
40. Baker and Baker, *WPA Oklahoma Slave Narratives*, 162–66.
41. Jones and Reynolds, *Coweta County Chronicles*, 189.
42. Ibid., 291.

CHAPTER 3

43. Anderson, *History of Coweta County*, 59.
44. Parks, *Parks-Atkinson Family Letters*.
45. Ibid.
46. Ibid.
47. Ibid.
48. William Thomas Overby mustered into Company A, Seventh Georgia Infantry, as a private on May 31, 1861. Known as the "Nathan Hale of the Confederacy," Overby was serving in the Forty-Third Virginia Cavalry, Mosby's Rangers, when he was caught by Union forces during a

skirmish in Front Royal, Virginia, in September 1864. Overby was hanged on September 23 after refusing to reveal the hiding place of his unit.

49. Parks, *Parks-Atkinson Family Letters*.

50. Candler, "Reminiscences of Life in Georgia, Part IV," 304.

51. Newnan-Coweta Historical Society, *A History of Coweta County*, 14

52. Jones, *McCook's Raid and the Battle of Brown's Mill*, 25.

53. Beers, *Memories*, 139.

54. Cumming, *Journal of a Confederate Nurse*, 215.

55. Beers, *Memories*, 139.

56. Cumming, *Journal of a Confederate Nurse*, 215.

57. Beers, *Memories*, 140–42.

58. Jones, *McCook's Raid and the Battle of Brown's Mill*, 64.

59. Beers, *Memories*, 148–49.

60. Jones, *McCook's Raid and the Battle of Brown's Mill*, 66-70.

61. Barron, *Lone Star Defenders*.

62. Beers, *Memories*, 152–53.

Chapter 4

63. Candler, "Reminiscences of Life in Georgia, Part V," 15–16.

64. Jones and Reynolds, *Coweta County Chronicles*, 188.

65. Ibid., 187.

66. Ibid., 194.

67. *Newnan Herald*, January 1866.

68. Jones and Reynolds, *Coweta County Chronicles*, 215.

69. Ibid., 204.

70. *Newnan Herald and Advertiser*, February 1898.

71. Ohio Historical Society, "African-American Experience in Ohio."

72. Atkinson, "Question of Lynching," 52–53.

73. http://lenny.gsu.edu/utils/getfile/collection/printed/id/1065/filename/1071.pdfpage/page/1.

74. *Newnan Herald and Advertiser*, January 1899.

75. Ibid., February 1899.

76. Ibid., January 1899.

77. Ibid., February 1899.

78. *Atlanta Journal*, March 1899.

79. Jones and Reynolds, *Coweta County Chronicles*, 336.

80. *Atlanta Constitution*, April 1899.

81. Wells, "Consider the Facts."
82. Ibid.

Chapter 5

83. Candler, "Reminiscences of Life in Georgia, Part V," 12–13.
84. Thompson, oral history.
85. Slaughter, oral history.
86. Evans, oral history.
87. Mansour, oral history.
88. *Newnan Herald and Advertiser*, March 1903.
89. Barron, oral history.
90. Newnan-Coweta Historical Society, *History of Coweta County*, 28.
91. Glover, oral history.
92. Clay, oral history.
93. Hunter, oral history.

Chapter 6

94. Gordy, oral history.
95. Anderson, 40–41.
96. Jones and Reynolds, *Coweta County Chronicles*, 208.
97. Ibid., 98.
98. Ibid., 104.
99. Ibid, 104–6.
100. Ibid., 199.
101. Camp, oral history.
102. Ibid.
103. Gay, oral history.
104. Glover, oral history.
105. Barron, oral history.
106. Roscigno and Danaher, *Voice of Southern Labor*, 16.
107. *Newnan Herald*, September 1934.
108. Ibid.

Chapter 7

109. "Cocking Affair," *New Georgia Encyclopedia*, last modified November 8, 2013, http://www.georgiaencyclopedia.org/articles/government-politics/cocking-affair.
110. Brattain, *Politics of Whiteness*, 103.
111. Evans, oral history.
112. Mottola, oral history.
113. Cook, "Governor Ellis Gibbs Arnall," 65–68.
114. Ibid., 4.
115. Anderson, 122–23.
116. Jones and Reynolds, *Coweta County Chronicles*, 140.
117. Ibid., 196.
118. Paul McKnight Jr., oral history.
119. *Coweta School Days*.
120. Williams, oral history.
121. Jones and Reynolds, *Coweta County Chronicles*, 544–45.
122. Scruggs, oral history.
123. McKnight Jr., oral history.
124. Cook, "Governor Ellis Gibbs Arnall," 65–68.
125. *Newnan Times-Herald*, September 1970.
126. Williams, oral history.

Chapter 8

127. Evans, oral history.
128. McKnight Jr., oral history.
129. Gardner, oral history.
130. Gay, oral history.
131. Totsie McKnight, oral history.
132. Herb Bridges, personal interview, 2003.
133. *Rome News-Tribune*, October 1986.
134. Haynes, oral history.
135. Notes from a presentation given at the Newnan Historic Train Depot in October 2015.
136. Suzanne Helfman, personal interview, July 2014.
137. Laura Reynolds, personal interview, July 2014.
138. Patty Gironda, personal interview, July 2014.

139. "Alonzo Herndon (1858–1927)," *New Georgia Encyclopedia*, last modified August 16, 2016, http://m.georgiaencyclopedia.org/articles/business-economy/alonzo-herndon-1858-1927.

140. "Horace King," *Encyclopedia of Alabama*, last modified May 26, 2013, http://www.encyclopediaofalabama.org/article/h-1245.

141. Clay, oral history.

BIBLIOGRAPHY

Books

Anderson, W.U. *A History of Coweta County from 1825 to 1880*. Newnan, GA: Newnan-Coweta Historical Society, 1977.

Baker, T. Lindsay, and Julie Philips Baker. *The WPA Oklahoma Slave Narratives*. Norman: University of Oklahoma Press, 1996.

Barron, S.B. *The Lone Star Defenders: A Chronicle of the Third Texas Cavalry, Ross' Brigade*. New York: Neale Publishing Company, 1908. https://archive.org/stream/lonestardefender00barr/lonestardefender00barr_djvu.txt.

Beers, Fannie A. *Memories: A Record of Personal Experience and Adventure during Four Years of War*. Philadelphia, PA: J.B. Lippincott, 1888. http://www.perseus.tufts.edu/hopper/text?doc=Perseus:text:2001.05.0242.

Bishop, W. Jeff. *Newnan*. Charleston: Arcadia Publishing, 2014.

Brattain, Michelle. *The Politics of Whiteness*. Athens: University of Georgia Press, 2004.

Cotter, William Jasper. *My Autobiography*. Nashville, TN: Publishing House Methodist Episcopal Church South, 1917.

Cumming, Kate. *The Journal of a Confederate Nurse*. Baton Rouge: Louisiana State University Press, 1959.

The Honors Program of Central High School of Newnan, Georgia. *Coweta School Days*. Columbus, GA: Brentwood Communications, 1996.

Jones, Mary G., and Lily Reynolds. *Coweta County Chronicles for One Hundred Years*. Atlanta, GA: Stein Printing Company, 1928.

Jones, Robert C. *McCook's Raid and the Battle of Brown's Mill*. Kennesaw, GA: RCJBooks, 2013.

Lane, Mills. *'Dear Mother: Don't Grieve About Me. If I Get Killed, I'll Only Be Dead.': Letters from Georgia Soldiers in the Civil War*. Savannah, GA: Beehive Press, 1990.

Newnan-Coweta Historical Society. *A History of Coweta County, Georgia*. Newnan, GA: Newnan-Coweta Historical Society, 1977.

Newnan Times-Herald. Coweta County: A Pictorial History, Vols. 1 and 2. Newnan, GA: Newnan Times-Herald Inc., 2001 and 2002.

————. *2015 Anniversary Edition*. Newnan, GA: Newnan Times-Herald Inc., 2015.

Roscigno, Vincent J., and William F. Danaher. *The Voice of Southern Labor: Radio, Music, and Textile Strikes, 1929–1934*. Minneapolis: University of Minnesota Press, 2004.

Schoolcraft, Henry R. *Archives of Aboriginal Knowledge*. Vol. 5. Philadelphia, PA: J. B. Lippincott & Co., 1865.

Wolak, Edward W., and Helen T. Wolak. *Life in Coweta County at the Turn of the Century, 1900–1919*. Moreland, GA: self-published, 1999.

ARTICLES

Atkinson, William Yates. "Governor Atkinson of Georgia on the Question of Lynching." *American Lawyer* 6 (January–December 1898): 52–53.

Candler, Myrtie Long. "Reminiscences of Life in Georgia During the 1850s and 1860s. Part I." *Georgia Historical Quarterly* 33, no. 1 (1949): 36–48.

————. "Reminiscences of Life in Georgia During the 1850s and 1860s. Part II." *Georgia Historical Quarterly* 33, no. 2 (1949): 110–23.

————. "Reminiscences of Life in Georgia During the 1850s and 1860s. Part III." *Georgia Historical Quarterly* 33, no. 3 (1949): 218–27.

————. "Reminiscences of Life in Georgia During the 1850s and 1860s. Part IV." *Georgia Historical Quarterly* 33, no. 4 (1949): 303–13.

————. "Reminiscences of Life in Georgia During the 1850s and 1860s. Part V." *Georgia Historical Quarterly* 34, no. 1 (1950): 10–18.

Wells, Ida B. "Consider the Facts." *Atlanta Journal*, 1899. http://www.wwnorton.com/college/history/america7/content/multimedia/ch19/research_02i.htm.

NEWSPAPERS

Atlanta Constitution
Atlanta Journal
Atlanta Journal-Constitution
Newberry Observer
Newnan Advertiser
Newnan Herald
Newnan Herald and Advertiser
Newnan Times
Newnan Times-Herald
Rome News-Tribune

WEBSITES

Encyclopedia of Alabama. "Horace King." http://www.encyclopediaofalabama.org/article/h-1245.

http://lenny.gsu.edu/utils/getfile/collection/printed/id/1065/filename/1071.pdfpage/page/1.

New Georgia Encyclopedia. "Alonzo Herndon (1858–1927)." http://m.georgiaencyclopedia.org/articles/business-economy/alonzo-herndon-1858-1927.

The Ohio Historical Society. "The African-American Experience in Ohio: 1850–1920." http://dbs.ohiohistory.org/africanam/html/html.

ORAL HISTORY INTERVIEWS

Clay, Wilbon, II. Oral history recorded by Mark Wilson. January 28, 1999. Newnan-Coweta Historical Society (NCHS) Archives, 27 Clark Street, Newnan, GA.

Cook, James F. "Governor Ellis Arnall: An Oral History," Georgia Government Documentation Project, Georgia State University, 1988.

Evans, Ollie Louise. Oral history recorded by Mark Wilson. April 5, 1999. NCHS Archives.

Gardner, Lillian Hand Stripling. Oral history recorded by Mark Wilson. March 23, 1999. NCHS Archives.

Gay, James. Oral history recorded by Mark Wilson. March 9, 1999. NCHS Archives.

Glover, Clifford Banks. Oral history recorded by Mark Wilson. April 27, 1999. NCHS Archives.

Gordy, Herbert Ezra. Oral history recorded by Mark Wilson. March 3, 1999. NCHS Archives.

Haynes, Sara Threatt. Oral history recorded by Mark Wilson. March 16, 1999. NCHS Archives.

Hunter, Jack and Kathleen. Oral history recorded by Mark Wilson, March 30, 1999. NCHS Archives.

Mansour, James. Oral history recorded by Mark Wilson. February 4, 1999. NCHS Archives.

McKnight, Paul, and Totsie McKnight. Oral history recorded by Mark Wilson. March 2, 1999. NCHS Archives.

Mottola, Virginia Starr. Oral history recorded by Mark Wilson. April 1, 1999. NCHS Archives.

Slaughter, Mary Fox North. Oral history recorded by Mark Wilson. February 16, 1999. NCHS Archives.

Thompson, Katie Freeman. Oral history recorded by Mark Wilson, April 15, 1999. NCHS Archives.

Williams, Sara Clay, and Angelena Scruggs. Oral history recorded by Mark Wilson, February 4, 1999. NCHS Archives.

LETTERS

Parks, Frances T. *Parks-Atkinson Family Letters, 1842–1867.* Transcribed in 1997.

INDEX

ABOUT THE AUTHOR

W. Jeff Bishop, an author and public historian, has lived most of his life in Coweta County. As executive director of the Newnan-Coweta Historical Society, Bishop heads programming, exhibits and development at the McRitchie-Hollis Museum and the Newnan History Center at the Historic Train Depot. For many years, Bishop wrote for the *Newnan Times-Herald* newspaper, as well as for other newspapers and regional magazines. In 2016, his original musical play, *Flies at the Well*, commissioned by the Newnan Theatre Company to tell the story of the 1948 John Wallace murder trial, premiered at the Wadsworth Auditorium. He also served as president of the Georgia chapter of the Trail of Tears Association, for which he performed research and documentation of Indian removal in Georgia. He resides in Newnan, Georgia, with his wife and their five children.

ABOUT THE NEWNAN-COWETA HISTORICAL SOCIETY

The Newnan-Coweta Historical Society interprets and preserves the historical, cultural and architectural heritage of Coweta County through its programs, exhibitions and collections while serving, engaging and educating the diverse communities of Coweta County and the surrounding region.

The historical society operates the McRitchie-Hollis Museum at 74 Jackson Street in Newnan and the Historic Newnan Depot (Newnan History Center) at 60 East Broad Street. Contact NCHS at P.O. Box 1001 Newnan, GA 30264, call at (770) 251-0207 or visit its website at www.newnancowetahistoricalsociety.com.

The McRitchie-Hollis Museum is the headquarters of the historical society. Open from 10:00 a.m. to 12:00 p.m. and from 1:00 p.m. to 3:00 p.m. Tuesdays through Saturdays, the museum features rotating exhibits that tell stories about the people of Coweta County and their history. The museum is housed in the former home of Ellis and Mildred Arnall Peniston. The home was built in 1937 and is located adjacent to the University of West Georgia satellite campus.

Visit us at
www.historypress.net
..
This title is also available as an e-book